MEDIUMISM

Mediumism

A Philosophical Reconstruction of
Modernism for Existential Learning

RENÉ V. ARCILLA

Cover art: Patricia Dahl, *Untitled*, oil on canvas, 72" × 60", 2009.
Photographed by Ingrid Roe.
Used by permission.

Published by
STATE UNIVERSITY OF NEW YORK PRESS
ALBANY

© 2010 State University of New York

For information, contact
State University of New York Press, Albany, NY
www.sunypress.edu

Production, Laurie Searl
Marketing, Anne M. Valentine

Library of Congress Cataloging-in-Publication Data

Arcilla, René Vincente, 1956-
 Mediumism : a philosophical reconstruction of modernism for
existential learning / René V. Arcilla.
 p. cm.
 Includes bibliographical references and index.
 ISBN 978-1-4384-2925-0 (hardcover : alk. paper) 1. Education—
Philosophy. 2. Learning—Philosophy. 3. Existentialism. I. Title.
 LB14.7.A733 2010
 370.1—dc22 2009008530

10 9 8 7 6 5 4 3 2 1

To Patricia, a history sublime

You are so young, so before all beginning, and I want to beg you, as much as I can, dear sir, to be patient toward all that is unsolved in your heart and to try to love the *questions themselves* like locked rooms and like books that are written in a very foreign tongue. Do not now seek the answers, which cannot be given you because you would not be able to live them. And the point is, to live everything. *Live* the questions now. Perhaps you will then gradually, without noticing it, live along some distant day into the answer.

—Rilke, *Letters to a Young Poet*

Contents

Preface

When you look at a painting like the one on this book's cover, what do you see? Leaving aside the particular features of the image, you might see a more or less interesting, more or less beautiful, work in the abstract style. Perhaps that style reminds you not only of similar paintings but also of works in diverse mediums that share the traits we have come to recognize as modernist. And seeing that, you might think of the history of this art movement and its distance from us today.

This book disputes the notion that modernism is outmoded. It aims to reconstruct some of modernism's characteristic features, transforming them from stylistic elements into principles of a pedagogical culture. This culture is different from the ones normally recognized today by multiculturalist educators. It abjures identity formation. Instead, its works teach anyone who is interested ways to cultivate an understanding of existence and to resist the distracting forces of consumerism. They accomplish this, as my title indicates, by artistically stressing their mediums.

To make this way of understanding modernism plausible, I engage with some of the most influential writing in modernist theory, particularly regarding works in the visual arts. I examine the reasoning of key essays by Clement Greenberg, T. J. Clark, and Michael Fried. Their theoretical points develop out of detailed exegesis, historical contextualization, and judgment of artworks they helped make crucial. Building on their insights and seeking to avoid the impasses they ran into, I try to point out a road not taken, one that connects their work to an unusual configuration of filmmakers, philosophers, and educational theorists, one that moves us from the realm of art history, narrowly conceived, to a project of cultural education. Although I am attentive to this road's basis in aesthetic responsiveness to concrete works, my exploration of it advances principally through philosophical criticism and speculation, that is, conceptual transformation.

Given what emerges as the stakes of this project, I hope this book will elicit interest from several kinds of audiences. I hope that critics, historians, and theorists of modernist art will find thought-provoking my new approach to appreciating the value of that art. Because this approach draws heavily on

existentialism, it should raise new aesthetic, cultural, and educational questions for philosophers working in this area. And because it proposes to support a pedagogical culture growing out of the conversation of liberal learning, I hope it will engage the energies of liberal educators and philosophers of education. Bringing these different audiences together is of course no small challenge. Readers in each are bound to find some of the relevant literature from the other realms unfamiliar. I have accordingly sought to walk a line between glossing enough of the thinking in these literatures to make it accessible to the uniniti-ated while delving deep enough into its complexities to make argumentative points of substance. My strategy has been to select a few key works to focus on in detail, employing them as motivators for the exposition of my argument, and to allude only to others that introduce necessary points of qualification. I prefer to err on the side of concision and directness in order to reduce the chance of confusing readers with too much esoterica.

One regret I have is that it has not proved feasible to supply reproductions of visual artworks. I have tried to minimize the impact of this by discussing works that are commonly known and resisting the temptation to draw atten-tion to the unsung. Many of these works are moreover viewable on the Web. As for the films I take up, I am glad to note that they are all available on DVD.

This book grew out of a number of nurturing environments and stimulating conversations. There is no higher, more voluptuous pleasure than to count such blessings. I first conceived of the book's argument in the library of the Interna-tional House of Japan, my favorite place for philosophical reflection. Later, I was able to concentrate on a draft of the opening during a sabbatical spent at the University of Tokyo. Over the years, this piece evolved in the warm climate created by my colleagues in the Department of Humanities and Social Sciences in the Professions, NYU Steinhardt. Parts of it benefited from my discussions with audiences at the Royal Danish School of Educational Studies and at the Graduate School of Education, University of Pennsylvania.

The faith put in me by the Arcilla and Dahl families was an inexhaust-ible source of support. Indeed, I am grateful to all my friends for their belief in this project. Many of them left their mark on the manuscript, including Grace Barrett, Norma Field, David Hansen, Patricia Rohrer, and Stephen Swords. Maxine Greene, in particular, nourished my confidence that this work could find receptive readers by the power of her example and by her close camaraderie.

As Gregg Peterson knows, most of the book is a record of aesthetic experi-ences and philosophical questions we have shared for decades. I hope it testifies as well to my appreciation of our ongoing exchange.

Three more friends made a big difference. Chris Higgins generously read some chapter drafts and gave me the benefit of his usual comprehensive and trenchant criticism. Philip Jackson did the same, and because he knows me so well prevented me from indulging in some of my typical excesses. As I completed my writing, Jonathan Zimmerman helped me immeasurably to find the right home for it.

SUNY Press has been just that. In addition to Jane Bunker, Amanda Lanne, Laurie Searl, and their colleagues, I would like to thank the Press's anonymous reviewers for their work and perceptive suggestions. I would also like to thank Ingrid Roe for the beautiful cover photograph and Alice Templeton for the index.

Saving the best for last, I am happy to affirm that I could have had no better conversational partner during this project than Patricia Dahl. In every way, I have written *Mediumism* for her.

Modernism: A Pedagogical Culture?

How might the fields of education and culture better support each other? This book is going to seek some initial answers to that question, both utopian and practical. Of course, as soon as you mention culture these days, many reach for the more skeptical query, whose? Culture*s*, we are reproved, belong to disparate groups with interests in excluding, dominating, or protecting themselves from others; these interests necessarily shape and find expression in any cultural work. As a first step toward opening education to this tense diversity, then, we should be upfront about the specific cultures, and interests, we each represent. I ought to declare the one or ones with which I identify and how they stand in relation to others.

So let me start there. As I see it, my culture emerged out of experiences in the early 1970s while attending college at the University of Chicago. The sixties counterculture appeared to be changing everything, and I was eagerly trying to catch up. More than Dionysianism, this culture represented for me a refusal to settle for the functional compromises associated with "adulthood," and a commitment to the experimental life. Still, I remained retrograde enough to attend classes and the ones that affected me the most, ironically, were those devoted to the Establishment's classic texts, "the best that has been thought and said." I found the whole idea of a Great Conversation about what it means to be human inspiring; it revealed something universal and eternal about my most fundamental quandaries and reassured me that in my loneliest moments I was in the company of seers.

A traditional high culture and an avant-garde populist one: yes, I did worry about being torn apart by my attractions to both of these, and my betrayal of each. But that worry also excited my imagination of what these cultures could have to say constructively to each other; it made me feel like I had my hands on some crucial koan. Probably one reason I took seriously even these cultures' most hyperbolic ideals is that I wanted their combined contradictions to come into acute focus. I suspected that if I could in a manner reconcile them, or at least bring them into sustained dialogue, I would find there my authentic self.

The Great Books and the Grateful Dead? I must be joking if I am claiming these as my culture today. Unless I am some kind of reactionary, surely I have unlearned the naïve pretensions and ideological collusions of such works by now and have outgrown the communities that once revered them—communities that themselves have largely passed away. Would I deny that most of what currently hypes itself as countercultural is merely, as Thomas Frank would put it, fashions in commodified dissent?[1] Or that Western high culture is based on the Imperial Monologue? Has my learning been somehow stuck in time, my culture mere nostalgia for daydreams of the tuition-paid moratorium?

Furthermore, I can imagine an incredulous reader thinking that what I call culture here hardly seems adequate to the term. A person's culture is rooted in the groups to which one voluntarily or involuntarily belongs. It would be more accurate to speak of one's culture or cultures being hybrid. In either case, a particular culture becomes especially meaningful for one when membership in the corresponding group makes a pronounced difference in one's life. One will tend to value one's ethnic culture more in societies where ethnicity matters in how one is treated. Now even in the ivory tower, surely, my race, gender, sexuality, and class—likening me to some and distinguishing me, often conflictingly, from others—shaped the course of my life more than the music I surrounded myself with or the books I read. Did not my socialization into groups in the above categories, my informal, mainly unconscious learning of what it means to be Asian American, masculine, heterosexual, and petty bourgeois in Chicago at this time, have more of an impact than any idealistic identifications? Is not this uneven, manifold, materialist positioning in society my true culture?

These are no less serious objections for being obvious. Perhaps, though, their reasoning adds up less to the conclusive untenability of my cultural understanding than to a need to elaborate it further. Let me see if I can translate them into two sets of constructive questions.

Granted that both the sixties counterculture and the Arnoldian culture of old-time liberal education are as such, for the most part and for good reasons, moribund. Are there nevertheless key remnants of these that could, and should, be preserved, even developed, in the present? Is there some culture that might bring these two sets of remnants together for some important purpose?

Granted that the cultures that mean the most to us are rooted in those social groupings that most affect our actual material and practical lives. Could an above culture of remnants be so rooted?

Before I take a crack at these, let me seize the opportunity to gloss that most slippery of terms, "culture." My remarks are hardly intended to be definitive—how could they be, given the long, contested history of the term?—but they are meant simply to suggest one way of figuratively understanding the term that may be useful.[2] Think of culture as the central nervous system of a community.

Individually, our biological nervous systems enable us to become aware of how the world affects us, to derive from that awareness intelligent decisions about how to respond to the world, and to take reflective responsibility for our identities over time. Culture, I am suggesting, facilitates these same functions for a community. It registers the community's experiences—not all of them, obviously, but those that attract popular concern and conversation. It derives from that register general, model judgments about how to live. And it summons an audience to recognize the experiences and models of conduct that its members have in common and to take responsibility for the welfare of this community. It is in this sense that a work of culture in conversation with other such works may be likened to a nerve transmitting a message that must be integrated into a whole network of such messages, forming self-consciousness. Culture, as such a self-consciousness, would be focused on what Raymond Williams calls its "basic element": the "effort at total qualitative assessment."[3]

Is there, then, a communal nervous system that usefully brings together components of high culture and the counterculture? Yes—modernism. Of course, how this may be is far from evident. It is not clear that modernism, understood initially as a movement in the arts, is even a coherent whole, let alone a full-fledged culture. Moreover, if it were, how it would combine high-cultural and countercultural elements requires explanation, since modernism of course postdates the ancient sources of Western high culture and predates the twentieth century, not to mention the sixties. Finally, and perhaps most problematically, even if modernism could be understood in the way I am proposing, there remains the inconvenient fact that it, like the other two cultures, is widely considered to be over. We are all postmodern now, no less than post-canon-worshippers and post-'68-ers, and while particular works from these pasts may shed light on our present, the idea that they could form as a whole our living culture seems, again, like nostalgic escapism.

What is modernism? Does it—did it—even exist? I imagine that many of us who try to get a handle on the subject must struggle with the same doubts that Franco Moretti did.

> Initially, to be honest, my project was entirely different. I was thinking about modernism—a theme on which I had already written on more than one occasion, and which I had been studying for years. During that time, however, Perry Anderson had been trying to convince me that so heterogeneous a category (Mayakovsky and George, Kafka and Proust, perhaps even Lawrence and Tzara) could be of little use: it was too contradictory, or too vague, to have real explanatory value. For a long while I thought Anderson was mistaken. Then I came to the conclusion that he was half right (and modernism should precisely be described as a field of contradictions). Finally, at a certain point, I decided it was I who was mistaken. Weary of trying to square the circle, I resolved to abandon modernism and broke off my original project.[4]

No doubt the category, like many others, can be grist for some skeptic's decon-struction, showing how its components are ultimately arbitrary, contradictory, and incoherent.[5] But then deconstruction being the double-edged sword that it is, one could use it equally to demonstrate that arguments debunking the idea of modernism tend to rely on modernist assumptions and devices. For what it is worth, I propose to build on the work that so many precursors have invested in giving this idea meaning. This is scarcely because I think I am better informed than Moretti or Anderson—far from it. I concur that there is nothing natural or inevitable about the idea. Yet I am looking in it, ultimately, for a different kind of "explanatory value." I am less interested in calibrating the comprehensive, historical order of the arts than in showing how an open-ended set of their works may be enrolled in the service of a specific project in the present. From here on out, while of course inviting criticism, I shall be striving less to establish categorical facts than to articulate the promise of particular speculative possibili-ties. For me, modernism is a concept whose significance is entirely pragmatic.

To be sure, the artists, critics, historians, and philosophers who have concerned themselves with this concept have hardly been unanimous. Most, especially at this late date, have distanced it from loose notions of modernism as art that is strikingly novel, fresh, or advanced, or as a taste for these quali-ties. Some have associated it with a distinct style or language characteristic of a historical period that reveals beauty and meaning (or ugliness and meaning-lessness). Features commonly associated with this style include not only self-reflexivity, dissonance, and inconclusiveness but also functionality, geometric perspicuousness, and so on.[6] Some, examining such various and conflicting stylistic features, have traced them to an overarching aesthetic philosophy, an "-ism" coincidentally or communicatively shared with significant variations, of how artworks should be made and appreciated with a sense of their timeliness. And then some have tried to explain how this aesthetic philosophy was shaped in turn, and held in place, by forces rooted in particular historical situations of modernity. These represent some of the most general ways of interpreting modernism. Within and between them, there remain refractory disagreements.

The idea of modernism that I am drawn to inherit is perhaps the most commonplace one: that based on the stress on medium. The medium of an art consists of a set of regular materials, instruments, techniques, and forms. The artist employs these to produce recognizable works of that art; in this sense, the medium constitutes the means of artistic production. Normally, such artworks, with their interacting elements, stimulate experiences of beauty, pathos, or meaning in audience members. Artworks often do this by repre-senting parts of the world or life in some special yet intelligible fashion. The same medium that enables an artwork to be produced also enables it to signify something. Conversely, the medium sets certain conditions for the artwork's production and signification. The process of signification highlights another

dimension of the medium: it constitutes a communicative interface between the artist and the audience. The medium places these two in a social relation.

Equipped with this rough notion of the artistic medium, we may wonder why it is that certain artworks—call them modernist—are evidently bent on stressing their mediums, on celebrating and threatening them. The two writers who have broken the most ground in responding to this question, defining modernism as such a response, are Theodor Adorno and Clement Greenberg. The former, most notably in *Aesthetic Theory*, explains how the stress represents an attempt to mournfully acknowledge, and check, the threat posed to genuine artistic aspiration by commodification.[7] Although I very much want to keep Adorno's concerns and insights in view, I would like to proceed from Greenberg's account. Adorno's critique of the current crisis of the arts expands to cover a larger crisis of reason in toto; this critical theory leads him to toil without prevarication and with painstaking patience in the contradiction of having constantly to undercut the very grounds of his own critique. Writing today on the other side of deconstructionism, so to speak, and having become disenchanted with the extremely scholastic fruits of such metalinguistic, paratactic, recursively ambiguous tours de force, I prefer to be more cautiously modest and to accept that the grounds of my criticism will only be incompletely apparent, let alone rational. I am ready to rely on, and be corrected by, that most human, all too human of instructors: experience. Hence my turn to the hardheaded New Yorker. Greenberg, James Elkins reports, "in the United States and in England, Ireland, Italy, Germany, Scandinavia, and France . . . tends to be considered the most important [art] critic of the second half of the twentieth century."[8] Fredric Jameson affirms that he is the "major theoretical figure of the late modern age and indeed that theoretician who more than any other can be credited as having invented the ideology of modernism full blown and out of whole cloth."[9] His theory is conceptually plainer than Adorno's, yet backed by close reading and criticism of numerous specific works; the data supporting it, as it were, is clearer. And Thomas Crow and Thierry de Duve, among others, have persuasively detailed a number of intriguing parallels between these two thinkers.[10]

Just as Adorno developed his concept of modernism in dialogue with works of primarily music and literature, so Greenberg's thinking is rooted in a career of judging works of the visual arts. By engaging at length with Greenberg and his critics, then, I will be initially rooting my understanding of modernism in approaches to sculpture and painting. Most of the examples I consider in passing in the next few chapters will come from these arts. My ultimate aim, however, is to explore how his theory of modernism can be extended and reinforced to comprise a culture of all the arts. Accordingly, when later in the book I try to support this revised theory with an examination of several concrete examples, I shall look to cinema.

Greenberg characterizes as modernist any artwork that is engaged in a project of Kantian self-criticism with respect to the question, what elements of its medium are necessary to works of this particular art? His classic formulation of this idea is in the late essay "Modernist Painting," although, as we shall see in a moment, some of his earliest essays are arguably even more crucial for getting the idea off the ground.[11] I shall be examining and developing this interest in illuminating the artistic medium at length over the course of this book; Greenberg's own elaborations may be found throughout much of his writing, particularly in *Art and Culture* and "After Abstract Expressionism."[12] As many know, Greenbergian modernism eventually bred a fierce backlash sharpened by antipathy to its author's notoriously peremptory manner as well as by the gold rush to all things postmodern. Currently, much of the art world treats him as a figure of ritual scorn. However, there has been some recent, sensitive criticism of his thinking by J. M. Bernstein, Crow, Arthur Danto, de Duve, and Jameson and an in-depth study by Caroline Jones.[13] As we will see, the critical responses of T. J. Clark and Michael Fried, arguably the two most influential critics and historians of modernist painting after Greenberg, have proved especially helpful for my purposes. What I would like to explore is how, in the stress on medium, there might actually be more at stake than the experience of beauty. I wonder if we might not be able to derive from this "mediumism," as I shall call it, a basic sense of who we are and what is the good for us. Such a philosophy would be at the heart of modernism as a culture.

This returns me to my claim about modernism's cultural components. What would substantiate it is a historical account of why and how modernism inherited important elements of high culture and anticipated—even influenced—those of the counterculture. Clark, particularly in his magisterial commentary on Greenberg, offers us such a history. "Clement Greenberg's Theory of Art" develops a critical interpretation of the cultural understanding that guided Greenberg's practice as a critic, focusing on his early, formative essays.[14] Greenberg situates the tradition of avant-garde art, which he and many others would later call modernism, in a crisis in bourgeois culture, one in which "all the verities of religion, authority, tradition, and style—all the ideological cement of society, in other words—are either disputed or doubted or believed in for convenience's sake and not held to entail anything much."[15] Although Greenberg does not delve into the reasons for this crisis, Clark draws out his implicit historical understanding of them from these essays' pointed Marxism.

Focusing on the key work "Avant-Garde and Kitsch," Clark observes that "it seems to be an unstated assumption . . . that there once was a time, before the avant-garde, when the bourgeoisie, like any normal ruling class, possessed a culture and an art which were directly and recognizably its own."[16] Writers and artists like Daniel Defoe, Stendhal, Théodore Géricault and others Clark lists, helped record the experiences with which this class largely identified. However, "from the later nineteenth century on, the distinctiveness and coherence of that

bourgeois identity began to fade."[17] Its culture slid into the crisis that eventually produced modernism. What precipitated this were pressures from the classes the bourgeoisie strove to rule. As Clark explains,

> "Fade" is too weak and passive a word, I think. I should say that the bourgeoisie was obliged to dismantle its focused identity, as part of the price it paid for maintaining social control. As part of its struggle for power over other classes, subordinate and voiceless in the social order but not placated, it was forced to dissolve its claim to culture—and in particular forced to revoke the claim, which is palpable in Géricault or Stendhal, say, to take up and preserve the absolutes of aristocracy, the values of the class it displaced. "It's Athene whom we want," Greenberg blurts out in a footnote once, "formal culture with its infinity of aspects, its luxuriance, its large comprehension." . . . Add to those qualities intransigence, intensity and risk in the life of the emotions, fierce regard for honour and desire for accurate self-consciousness, disdain for the commonplace, rage for order, insistence that the world cohere; these are, are they not, the qualities we tend to associate with art itself, at its highest moments in the Western tradition. But they are specifically feudal ruling-class superlatives: they are the ones the bourgeoisie believed they had inherited and the ones they chose to abandon because they became, in the class struggles after 1870, a cultural liability.[18]

In order to present less of a target to working-class discontent, particularly after having so conspicuously affirmed with this class a democratic rhetoric that helped overthrow the aristocracy, the bourgeoisie found it advantageous in the late nineteenth century to downplay and camouflage its class identity. This meant giving up any claim to a distinctive culture or communal self-consciousness, let alone one that trumpeted inherited "ruling-class superlatives." Aristocratic high culture was let go. In its place, the bourgeoisie manufactured a new "popular" culture, one that purports to belong to all of us classless individuals. Such a culture functions to flatter, excite, and distract so that we can stand another Monday morning—quietly overlooking the fact that not everybody needs such mollification. Indeed, for some of the latter, it constitutes a lucrative market; as a result, commercial considerations tend to supplant aesthetic ones in its works, "hence what Greenberg calls kitsch. . . . It is an art and a culture of instant assimilation, of abject reconciliation to the everyday, of avoidance of difficulty, pretense to indifference, equality before the image of capital."[19]

This crisis, where an unabashedly challenging, genuinely communal culture is being replaced by a pandering, pseudouniversal, mass one, is what gives birth to modernism. Modernism is a movement that dissents from this development. It tries to hold on to "bourgeois art in the absence of a bourgeoisie or, more accurately, . . . aristocratic art in the age when the bourgeoisie abandons its claims to aristocracy. And how will art keep aristocracy alive? By keeping itself alive, as the remaining vessel of the aristocratic account of experience and its

modes; by preserving its own means, its media; by proclaiming those means and media as its values, as meaning in themselves."[20]

A couple of things are happening here. First, a fraction of the bourgeoisie is reacting against most of that class's support for the emerging culture of kitsch by asserting the contrary values of traditional, aristocratic culture. To do this, the modernists have to avoid reproducing the academic look of traditional culture, since kitsch culture, especially at its inception, is largely about the cheap simulation of such forms to trade on their prestige. Instead, modernism strives to put old wine in new bottles, traditional aesthetic virtues in futuristic, less exploitable forms.[21] A similar insight constitutes the cornerstone of Adorno's theory: in order to be honest, artists in this historical period of crisis have to bear witness, in their forms, to the pressure to reduce aesthetic value to exchange value. The other thing going on, though, is that this bourgeois coterie understands itself to be claiming and projecting not class values, but purely artistic ones, separate from those that guide and matter to everyday life. These artistic qualities are considered the "repository, as it were, of affect and intelligence that once inhered in a complex form of life but do so no longer; they are the concrete form of intensity and self-consciousness, the only one left, and therefore the form to be preserved at all costs and somehow kept apart from the surrounding desolation."[22] Modernism attempts to save these qualities in works that disengage from the representation of their milieu, in formally self-reflexive sanctuaries of abstraction.

How it pursues this project of formal resistance and shelter leads us back, as Clark indicates in the penultimate quote above, to the famous stress on medium; I shall commence my investigation of that in the third chapter. For our present purposes, this history of Clark's that I have sketched here illuminates how modernism emerges aspiring both to inherit and affirm traditional high culture and to protest against contemporary kitsch culture. It is in this sense that I call it a marriage of high-cultural and countercultural elements. Clark brilliantly dubs this union "Eliotic Trotskyism."[23] Indeed, as an example of how easily a modernist can shift between one or another of these emphases, consider the step in the filmmaker Jean-Luc Godard's career, which seemed a baffling jump at the time, from the Maoist *Vent d'est* (1969) to his *Sauve qui peut (la vie)* (1979) and the even more elegiac cinema after that, with the interjacent *Tout va bien* (1972) containing almost equal amounts of insurrectionary derision and rueful soulfulness. For those of us who still believe that there is a way these two kinds of elements can fit together into a coherent and compelling communal consciousness, modernism would appear to be the supporting tradition.

Yet this history also casts light on what has become increasingly dubious about this faith. Modernism is the culture of a class that no longer wishes to claim its identity; it is bourgeois culture disowned by its progeny. In response, it tries to stand for purely aesthetic values, but as Clark convincingly argues, who is finally going to be interested in works too abstract to even refer to our

practical lives? Small wonder that the modernist protest seemed finally point-
less, if not exasperatingly cultish—a defense of values that cannot really matter
anyway. While some critics, like Danto, have linked its demise to the cramped
dogmatism of its aesthetics, particularly its "metanarratival" tendency to exclude
other approaches to art-making with its demand for progress, Clark, modulating
at the end of his essay from interpretation to criticism, finds modernism fall-
ing fatally into social irrelevance between two stools.[24] On the one hand, the
bourgeoisie has no use for modernism's aristocratic values because they dissent
too much from its *faux* populism. On the other, the working classes who are
in a position conceivably to overthrow that culture have no use for dissent in
the name of such values. Without an audience to which it could really make a
difference, modernism became an embalmed curiosity only for posterity.

Or did it? Terminally, and without possibility of revival? Unlike postmod-
ernists eager to kill the Father and move on, with gleeful irony, to the new and
improved, Clark pronounces the death of this culture with some sorrow and
with apprehension about the rut its passing has left us in. This comes through
especially in his later writings.[25] But I wonder if he has not written off too
quickly modernism's once and future audience. He characterizes this audience
as a shrinking fraction of the bourgeoisie, alienated both from the mainstream
of its class and from the working classes. Although this may well have been
true throughout most of modernism's history, I am not sure it must be so today.

My reason for optimism is that I believe modernist culture *can* make a
practical difference to us, as individuals and as members of a community defined
by that difference. This is the central theme of this book. The difference is one
rooted in the antikitsch, anticommercial stance that Clark identifies in modern-
ism's origins and treatment of its medium. True, it is not an anticapitalism that
proceeds from a working-class identity and so, as he notes in a later book, this
political stance is bound to sound to some wishful and flimsy.[26] From such an
unlikely premise, then, let me jump directly to the implausible punch line, in
order to measure roughly the burden of argument I intend to take up.

My hunch is that modernism can be a culture that establishes and affirms
the distinction between consuming and learning, between identifying oneself as
a consumer, part of a market, and identifying oneself with other learners in an
ongoing, conversational adventure. Indeed, it would proceed from the realiza-
tion that the prevailing culture of consumerism gravely endangers learning. In
the tensions between these two groups and cultures—which are related to, if
not identical with, those between the central capitalistic classes—modernism
would find its politics.

By "consumption," I am thinking of what exactly? Conventionally, we lump
together under the term those activities in modern societies that are contrasted
with production. This dichotomy is linked to that between leisure and labor,
as well as that between receptivity and expressivity. This chain of binaries,
however, tends to naturalize consumption to the degree that consumption

is made to look as necessary to us as leisure and receptivity. However, just as socialists have argued that labor and expressivity could be made to resemble more of an art than a mechanical production, I would like to suggest there is a practice of receptivity that does not involve consumption or the restless casting around for punctual, disjointed, fleeting pleasures and that can be placed at the center of our leisure: learning. Modernism has the power, I believe, to convert consumers into learners, their defining opposites, who progressively deepen the satisfaction they receive from life.

At last I bring education back into the foreground of this picture. But what kind of education am I talking about here: artistic and literary, aesthetic learning? That seems so narrow, effete a taste, hardly a force that could constitute a counterweight to the ubiquitous and implacable drumbeat urging us to buy. Besides, such an education is itself big business, as are all the others on offer. If I hope to play out this argument, I need to explain why there is an education that is not a mere option for those of us who can afford it, but a necessity for all. I need to explain why it cannot be commodified or cultivated by anything we consume and how it can be supported by an alternative culture of modernism. As a placeholder for such an explanation, let me give this education the rather exotic name "existential learning." One thing that stimulates and nurtures existential learning, I shall be arguing, is modernist pedagogy. The culture of modernism serves as a nervous system for the community of existential learners, helping them to develop and to defend themselves from the society and culture of consumerism.

Modernism for existential learners: even this preliminary announcement of my theme indicates that I am separating modernism somewhat from its tight association with modernization. If we follow all the way through on the logic of the stress on medium, I shall argue, we will discover that the mode of experience brought to our attention by this emphasis is ultimately not only that of modern people. It is that of learning beings. For this reason, my philosophical reconstruction of why modernism can still make a difference to us concludes by renaming this pedagogical culture more explicitly, "mediumism." (And if the proclamation of yet another "-ism" amuses as a piece of modernist camp, all the better. Humorlessness is fatal to seriousness.)

Why should modernism, its historical legacy and its current viability, matter to educators? How might appreciation of this educational value affect the way we support mediumism today? Responding to these central questions is how I propose to explore the relation between culture and education in this study. Some will doubtless be disconcerted that there has been little mention of the diversity of, and conflicts between, the racial, ethnic, gender, and sexual cutlures that have preoccupied us for the past few decades. They will probably wonder how an education that is not explicitly multicultural could claim to be responsibly cultural at all. I plan to address these concerns at the appropriate moment in my argument; I shall explain my reservations about cultures of

identity. In the meantime, I would ask the reader at least to entertain a different way of fitting together culture and education, one that I am confident would help heal, rather than exacerbate, our cultural conflicts. We are all familiar with the broad idea of a multicultural education for the tolerance and appreciation of different cultures. Consider now a specific yet capacious mediumist culture for the support and protection of our universally necessary, existential learning.

I realize too that my willingness to talk without batting an eye about saving elements of aristocratic culture will mark me in the eyes of some as an irredeemable elitist. Have I forgotten, or worse, the fact that "there is no document of culture which is not at the same time a document of barbarism?"[27] To the contrary, I want to preserve the charged distinction between civilization and barbarism in as scrupulous and detailed a form as possible. It may be that virtually all works of culture are morally myopic or contradictory in the way that Edward Said, for example, has contended that *Mansfield Park* is.[28] If that were the case, however, would we not have all the more motivation to discern and affirm the aesthetic and moral values in such works, so that we can condemn *on the basis of that affirmation* their disappointing lapses and betrayals? My worry about the Red Guards' treatment of politically incorrect authors, clapping both their virtues and their vices into the stocks, is not that it is too severe but that it may end up accustoming us to the notion that aspirations to elevation are always merely apologies for debasement. Why then bother apologizing? Far from ushering in the Republic of Virtue, this version of the Terror puts us on the road to a coarse and complacent cynicism.

Finally, I should note explicitly what I would think is obvious by now: I do not restrict education to schooling. Many participants in the recent debates on cultural education view the stakes as coming down to how, and which, culture is taught in the classroom. Although I share that concern, to be sure, I want to keep it connected to one that is perhaps more utopian and certainly less attended to, namely, how the realm of public culture beyond the schools—that of the media, museums, architecture, and so on—can be reclaimed for education. How we might live in a school from which we never graduate.

This chapter has introduced the possibility of viewing modernism as a viable, pedagogical culture; the rest of the book can be adumbrated as follows. In the next chapter, I try to characterize more fully the existential learning proper to modernism. I start from Michael Oakeshott's idea of liberal learning, which, following the traditional practice of liberal education, is rooted in our nature as free beings. After elucidating some of the principal characteristics of this learning, I explain how Jean-Paul Sartre, who shares Oakeshott's appreciation of our deep freedom, points to a serious dilemma: how could liberal learning avoid immuring us in bad faith? In response, I try to revise this learning in the light of the emphasis that Martin Heidegger and Ludwig Wittgenstein place on existence. Existential learning would encourage us not only to meet practical problems with intelligent solutions but also to find in these problems regular opportunities for coming back

to, and coherently advancing from, the experience of questionable existence—an experience that is at the core of our authentic being.

Chapter 3 considers in more detail what it would mean to return to this experience. How might modernism help bring us back to it? I address this by resuming the discussion of Clark's response to Greenberg, focusing on the latter's stress on the medium of modernist works. Clark discerns in this stress a central act of negation. I try to seal the connection between this negation and the experience of existence by exploring an analogy between Clark's medium constituted by, and registering, negation, and Sartre's account of consciousness constituted by, and registering, nothingness. The medium and consciousness are what enable us to become aware of whatever exists. Yet as hosts of a negativity distinct from such beings, they also estrange us from the world. By drawing attention to the medium of a work of artistic representation and, by extension, to the medium of our awareness itself, to our consciousness, modernist works remind us of the alien and questionable, nameless dimension of ourselves. Beneath all we have assumed, including our own identities, there is our deeper strangerhood.

This compelling experience of negativity would appear to trap us in a dead end. How can we go on; how can we advance constructively from an experience that dispossesses us of everything familiar? I respond to this in chapter 4 by turning to an alternate understanding of the modernist medium. Fried takes issue with Clark's emphasis on negation; he characterizes the medium rather as a site affirming "presentness." I examine and critically revise Fried's argument, developing out of it a moral orientation. The medium, it appears to me, has the potential to disclose the Present as the good for us, a good that shows us how we conscious beings should live. It teaches us how to accept, rather than assume, our existence. Existential learning thus completes itself in the move from an acknowledgment of our true condition as strangers, to this ethical presentmindedness. And what can facilitate this learning are modernist works that stress their mediums in ways that combine, and reconcile, both Clark's and Fried's emphases.

The previous chapters aim to develop a theory of the mediumist artwork as a pedagogical work for existential learning. If we stopped here, however, the theory would appear unduly idealist in that it evinces little appreciation of its concrete, social context. If existential learning is so natural, then why do so few actually interest themselves in it? Why is postmodernism today's watchword? Rather than seeing this as disproof of the theory's factual claims, I hear in it a call to work out its politics. Suppose mediumism were being marginalized by a quasiculture occupying the main stage of our society. As evidence for this hypothesis, can we discern how the same features that would be centrally constitutive of this hegemonic culture would be also necessarily opposed to mediumism? Chapter 5 will examine how the forms of immediacy favored by our mass media propagate a kind of absentmindedness that not only dispels social discontent but blocks existential learning. To the extent that mediumism forms

an idealistic culture of existential learning, then, it constitutes a counterculture as well. Anticonsumerism is its politics.

With these fundamentals of a theory of mediumist works and culture in mind, I shall turn in the sixth chapter to some concrete examples. I want to start to test the theory against specific works, especially those outside its original domain of the visual arts. To that end, I examine four contemporary films: Abbas Kiarostami's *Taste of Cherry*, Hou Hsiao-Hsien's *Café Lumière*, *Rosetta* by Jean-Pierre and Luc Dardenne, and Theo Angelopoulos's *Ulysses' Gaze*. These raise questions about our existential condition and the limitations of commercialism by drawing attention to the cinematic medium. They constitute guiding examples of mediumism.

By way of summary, my seventh, concluding chapter will plot the main theses of this reconstruction of modernism onto a triangular diagram that Christopher Higgins has formulated to specify the elements of any one, coherent concept of education for the purpose of critical comparison with others. While some people will likely continue to disagree that the cultural education constituted by these theses ought to take precedence over other learning projects, others, I hope, will find its capacity to stand comparison with such projects inviting. They may come to recognize themselves as mediumist educators. I point to some promising directions for the work of such educators. The chapter closes by returning to the book's epigraph, a passage from Rainer Maria Rilke that once upon a time led me to modernism. It seems fitting to finish by rejoining the scope of what remains to be elaborated in this theory to the hope that gave the theory birth.

CHAPTER TWO

Existential Learning

Although existentialism may no longer be in the news, as in Willy Ronis's famous photograph, the word "existential" regularly is.[1] We read about brooding, "existential" thrillers, or stark, "existential" forms, or the dissonant crescendos of an "existential" nightmare. It is easy to make sport of such Arts and Leisure prose, but clearly the term is common currency. "Existential learning," though, sounds dubious.[2] The previous cases refer to some kind of extreme, anguishing experience; exam dreams aside, is not normal, unnewsworthy learning a much less melodramatic affair?

So what could this learning be? As a first step toward redescribing modernism as a pedagogical culture, this chapter will try to work out a theoretical answer to this question. One touchstone at hand is the notion of freedom. Jean-Paul Sartre's existentialism, of course, is devoted to elaborating what it means to be a free being. And Michael Oakeshott, for one, has reminded us that liberal learning, the quest for self-understanding in liberal education, proceeds from a fundamental acknowledgment of our essential freedom. His classic essay "A Place of Learning," one of the most well-argued apologies for liberal education, presents us with an elegant and precise explication of his rationale for this learning.[3] Could existential learning, then, be simply liberal learning garnished with an explanation of its ontological conditions?

To explore this possibility more seriously, I want to start by focusing on the idea of freedom in Oakeshott. Although insightful, this idea, I worry, provides in the end somewhat uncertain support for liberal learning. It fails to take into account the Sartrean problem of bad faith. I shall suggest how it might be buttressed, therefore, with a sense of existence, where the realization that we exist, more unsettling than obvious, calls for a learning elaborated further in a particular direction. "Existential learning" would be the name for how we take responsibility for the fact that to exist at all is to be in question and that the learning that responds to this condition is not something we undertake to achieve an end—an instrumental practice—but the way we are ourselves. It

would indicate a natural necessity that demands to be better recognized by our educational institutions, one that modernist culture can address.

FREEDOM

Liberal education: an education in the liberal arts, an education appropriate for the free person; such goes the standard gloss of the term. By free person, furthermore, we usually mean someone who regularly exercises independence and self-reliance, someone who is capable of autonomy. And today in the democratic world, we are all presumed to be so capable, regardless of our given social stations. Liberal education, accordingly, comprises an education that promotes practical freedom, one that teaches us how to claim constructively and enduringly our autonomy and why that is rationally good. Evidently, this education shares many of the precepts of political liberalism, as Meira Levinson has recently argued.[4] More generally, its prominence appears to be a product of the larger ethic of self-assertion that separates our modern age from the medieval past.[5]

The practice of liberal education, then, posits in learners a germ of freedom. Yet it also makes freedom something that must be for the most part achieved. We each need this education because, in spite of our potential, we are born largely dependent on and subordinate to others such as our parents. As we release ourselves from others' foreign direction—direction that we learn to see as confining—we develop our autonomy. When on the contrary we see that some such guidance accords with our own considered thinking, we learn to recognize what is reasonable. Sorting all this out is bound to take considerable time and effort.

We have to admit, therefore, that this commonsense conception of liberal education is to some degree misleading. This education is less appropriate for the free person than for someone who wants to become free, or at least freer. Indeed, it would be more accurate to say that the model liberal learner is a significantly unfree person. As he becomes increasingly aware of his constraints, of his situation of mixed dependence and independence, he may come to regard autonomy as a desirable goal that he could realize. And we could help teach him how.

Now it may be that this infelicity indicates merely a need to *préciser* our conception. After all, nothing I have said impugns the appeal of this education: who would not want to become freer? But I also think it broaches a question at the very root of our educational practices. Might there not exist a learning that proceeds from recognition not of our partial, promising freedom but of our absolute freedom? Could there be some sense in which we must start out as, and remain, beings that are completely free? And if that is so, could there be an education—a more genuinely liberal, freedom-loving education—that does not seek to enhance what cannot be further enhanced but rather helps us learn to live with the challenges of this condition?

This possibility comes to light when we consider Oakeshott's explanation of how freedom is joined to learning. Here is how he defines the former idea in

"A Place of Learning": "This inherent 'freedom' of a human being lies not only in his ability to make statements expressing his understanding of himself, but also in the world being for him what he understands it to be, and in his being what he understands himself to be. A human being is 'free,' not because he has 'free will,' but because he is *in* himself what he is *for* himself."[6] Freedom is not primarily the power to choose. It is our capacity to understand the world and ourselves and to express this understanding in words and deeds—thereby *being* that understanding. We understand something when we recognize that that thing has a particular significance for us, which does not necessarily entail getting its nature objectively right. "The bike's shininess gives me such a thrill": this represents a valid understanding, even if I am later persuaded that the thrill is more truly reflective of commodity aura. Nothing is more important than this capacity of mine, because from it bikes and other things emerge, and I emerge as the person who understands these things in a distinctive way. The world exists as a world for someone, and it can be a certain way for that person if and only if he or she understands it as such. Without the person's capacity to understand, this world would not exist at all.

In what way does this capacity make us free? "I use the word 'free,'" Oakeshott explains in a contemporaneous text, "because I am concerned here with the formal detachment from certain conditions which is intrinsic to agency."[7] To act, our minds must be free from conditions of causal determination; they must be more than a product of chains of cause and effect, more than an unconscious process of adaptation. Reflex movement is not, strictly speaking, action, and the language of brain activity is different from, although related to, that of mindful agency.[8] True, one always starts in a situation that is mainly not of one's making and that shapes one's conduct more than vice versa. Still, "if this situation were one of 'organic tension,' peculiar to himself or characteristic of his biological species, if it were some other condition of himself or of the world which was imposed upon him and which he suffered without having to understand it, or if he were himself the mere battle-ground of arbitrary impulses or the mouthpiece of a god, then he would not be 'free.' But as a reflective consciousness his situation is necessarily an understanding and as an understanding it is necessarily his own."[9] The man here, like all of us, is situated in a world that is very much independent of him and his wishes, but how he is so situated is through an act of understanding, of "reflective consciousness," that constitutes who he is. I shall delve deeper into how understanding proceeds from consciousness in the next chapter. For our purposes at present, we should remark that his act is inherently his and is therefore free because it cannot be determined by anything outside the mind that understands.

To be sure, this does not mean that that mind is insulated from the world; understanding is always *of* something. Nor is it immune to others' influence. As it seeks to apprehend a particular object, however, the object and how it is viewed by others are prevented from simply determining the process, in the

way that a pattern of light determines a photographic plate, because the process is complete only when we each, individually, take responsibility for it. At the end of the activity that produces understanding, there must be a self-conscious affirmation of that understanding; after working out Oakeshott's philosophy in a discussion with friends, for example, I must think to myself, "Yes, now I see." Oakeshott would call this affirmation an acceptance of responsibility because it necessarily broaches the possibility for me who affirms to later declare, if I change my mind on my own accord, "No, I don't get it after all." One moment I may say I understand, and the next, the opposite, but at no time *must* I do one instead of the other. Nor is it possible for someone else to observe, "He thinks he understands, but he really doesn't"—at least, again, in the way that Oakeshott joins the concept not to correctness but to meaningfulness. Understanding is strictly a first-person speech act (although it is often not exteriorized). It is my charge, which I can of course evade or profess indifference to but which I cannot absolve or pass on.

This idea of responsibility insists that there is a moment in the process of understanding, and an inner realm of ourselves, that is irreducibly solitary. As we make up our minds, we are alone with our thoughts. Although these thoughts often arise in conversations that relate us, more or less enduringly, to any number of interlocutors, their meaningfulness has to be at some point a matter for individual self-examination. Now, this insight might seem to challenge prevailing wisdom about the importance of relatedness, community, and communication, but that would be a needlessly defensive interpretation. It would be more sensible to remark that the sole and the common, solitude and community, isolation and communication, are complements, not opposites; they indicate equally necessary dimensions of our nature. Each requires cultivation. Indeed, our responsibility for our own minds extends beyond the plain acknowledgment that something is understood by me only when I say so. Before I can claim understanding, I must first strive for it; it is not an automatic or effortless process. This is another reason that understanding is free from external determination—it is a work of learning: "When the human condition is said to be burdensome what is being pointed to is not the mere necessity of having to think, to speak and to act (instead of merely *being* like a stone, or growing like a tree) but the impossibility of thinking or feeling without having slowly and often painfully learned to think something. The freedom of a human being inheres in his thoughts and his emotions having had to be learned; for learning is something which each of us must do and can only do for ourselves."[10] Nobody is born knowing how to make sense of things or with the words to do so. Nor can these skills and languages, rooted in particular times, places, and companies, be simply given to one, as we give measles shots or program computers. They can only be acquired, taken in, by an active learner, one who is willing to subject himself or herself to, in Henry James's marvelous phrase quoted by Oakeshott, the "ordeal of consciousness."[11] Who would think that

simple awareness can be a trial? Yet an instant's reflection reminds us that it takes work to figure out what we are aware of. In this ordeal, there are risks: we can become lost, discouraged, humiliated, enslaved, or corrupted; we may give too little of ourselves to the labor or too much to a simulation of it. But this is the only way to become ourselves: individuals with each our own self-chosen, distinctive ways of understanding the world. I am my understanding; since this understanding has a history, I am also that history, my learning.

This last point elucidates why Oakeshott's first words in the essay are, "We are concerned about ourselves and what we may be said to know about ourselves."[12] The most natural thing in the world, self-interest, is a concern as well about self-ignorance. Liberal learning is above all learning who one is. I learn how to exercise, and take responsibility for, my freedom to understand the world, and thus I familiarize myself with the humanity I share with others. And simultaneously, I learn to understand the world in specific ways and to recognize those ways as unique to myself. This process is altogether distinct from practices of instrumental learning. The latter train me in various means of gaining control over the world and satisfying my wants. These practices assume that I recognize myself as, above all, a bundle of desires that need to be gratified. Good reasons exist for doing so. But anyone with a smattering of history or an acquaintance with less technological cultures knows that those are not the only terms in which human beings have understood themselves. If we are to consider seriously alternative terms as live possibilities for ourselves—ones that enable me to believe, say, I am a soul who needs to purify my desires, or a will who should affirm their eternal recurrence, or Emptiness without them—then we need to learn about these terms in a way that does not view them as more or less efficient means to given, fixed ends.

Notice that a break is starting to open up between the conventional notion of liberal education and Oakeshott's. The former aims to extend our given autonomy. It begins not by questioning that autonomy but by claiming it; the liberal learner realizes that he does not want to be what others expect him to be. His liberal education consists in learning how to free himself from the power of those expectations and to govern himself. Because it proceeds from a clear, unproblematic desire, then, it may be categorized as a kind of instrumental learning. In contrast, Oakeshott's liberal learner does not know who she is or what she wants. Her learning proceeds from her freedom from any sort of determination and so from her fundamental need to understand the world and herself. In the face of this predicament, this liberal learner does not even know whether autonomy is a good thing. Her challenging freedom to understand, I would claim, is prior to any affirmation of a freedom from the rule of others.

There is much more to say about the depth and detail of Oakeshott's vision of liberal learning. Two or three more points will have to suffice. One is that Oakeshott emphasizes that this learning is necessarily lifelong, because human life is an adventure without a script; it is a speculative essay. Another is that

our liberal learning is best stimulated by interactions with other liberal learners that are not disputational but conversational. Both of these points stem once more from our freedom. Because I am responsible for affirming my own understanding and the learning that leads up to and beyond it, I cannot take any model of human life, however attractive, as definitive, as more than optional and provisional. Even if I consider myself steadfastly loyal to one, I have to check that the model truly makes satisfactory sense of each new, unpredictable experience of mine—more sense than other available models; the only way I can stay in touch with myself is to put my self-understanding regularly to the test. This means that I continually need to examine myself critically through the eyes of others. Liberal learning requires membership in a particular kind of community, one inviting perpetual learners to exchange criticism such that we reflect on our common ordeal, on the one hand, yet respect and treasure self-consciously divergent responses to it, on the other—responses authorized by nothing more or less than a responsible act of understanding. Hence Oakeshott's inspiring, utopian image of culture as a place of learning where the relations between voices, personal and textual, are "not those of assertion and denial but the conversational relationships of acknowledgment and accommodation."[13] Such voices both articulate intimations of what we may each be and encourage us not to be "disconcerted by the differences or dismayed by the inconclusiveness of it all."[14] Above all, they urge us to take seriously the task of owning our understanding by reflectively consenting to it. Writing that serves as a forum for these voices would accordingly aspire to the same spirit.

I realize "utopia" tends to be a scoffer's word these days, but it is actually important for my purposes to underline how utopian Oakeshott's thinking is here. The reason is that, in other writing, Oakeshott declares himself a political conservative because he is skeptical about rationalist, utopian social reform.[15] He equates the appeal of the latter with the temptation to erect a Tower of Babel. But I want to suggest that his idea of culture here, where the free learning of all is the condition for the free learning of each, figures as a version of such a tower, designedly polylingual, to be sure, but reaching above our animal cares. It guides a project for making society more human. As such, I shall argue in chapter 5, it in fact calls for a much more radically constructive politics than Oakeshott's own.[16]

Although this is barely a sketch of how liberal learning rests on freedom according to Oakeshott and of why this learning would be better entitled to the name "liberal education" than efforts to promote autonomy, it perhaps already betrays certain strains, particularly in the observation that no self-understanding is destiny. What evidently *is* destiny, strangely, is our freedom from destiny. In Sartre's famous phrase, "we are condemned to be free."[17] To be sure, we ought to guard ourselves against being overly impressed with such paradoxical formulations. A more careful way of putting the matter might be that freedom is a kind of destiny, a kind of state that we always return to, in the same way

that white is a color: it may be reasonably considered a color or not a color, but for practical purposes nothing hangs on this choice. Still, even if one does not want to call this exactly a problem in Oakeshott's account, it is a troubling perplexity that when we seek to understand ourselves and the conditions of our understanding, we discover that we are necessarily determined to be free.

A second, closely related riddle adds significantly to the unease. What good is the freedom to understand one's world and oneself if that same freedom undermines such understanding? I am thinking of the problem of bad faith that Sartre illustrates, among other places, in the famous example of the café waiter.[18] The waiter cannot *be* a waiter; he can only *try* to be one. What stands in the way is precisely his freedom. As he dashes between tables, maintaining a professional demeanor, he assumes responsibility for understanding his situation and identity in a waiterly way, thus taking on the possibility of understanding it differently. The more serious and the less of a dabbler he is, the more he wants waiting to fit him like a glove. Yet, unlike the stone that must simply be a stone, he has constantly to negate the possibility of not being a waiter—of, say, walking off the job and into a getaway car; he could not consciously be one otherwise. In doing so, this dedicated man negates the very freedom he exercises and claims to be what he cannot be: a natural waiter through and through. His effort, which is free, contradicts his identity, which is supposed to be determined and hence unfree. In Sartre's baroque formula, "[he is] a waiter in the mode *of being what [he is] not*"; we can more prosaically characterize the predicament as that of a free man trying to shed his freedom, to understand himself as a definite thing, to define himself.[19] Such a project in bad faith is futile: the resulting self-understanding stays equivocal, the effort to live by it, theatrical. So what is the point of this freedom if it leads me not to myself but to a self-conscious restlessness palpably beside myself?

In a sense, Sartre anticipates the now familiar concern that with greater external independence comes more severe inner rootlessness and disorientation. He exposes the naïveté of thinking of autonomy as an unqualified good. Citizens of a democracy that respects our natural freedom are supposed to make up their own minds for themselves. Their thinking should not be subject to any external authorities. However, if everything that could guide understanding is kept at a distance, and mistrusted as a manipulative influence, then would not their understanding of who they are, and what they really want, be bound to appear either arbitrarily fixed or endlessly incomplete and therefore demanding of more and more inconclusive attention? I should not be who you expect me to be; I should be myself. But how can I understand myself if I cannot take seriously the views you have of me? In this respect, freedom can start to resemble a tyrant who leaves me alone in isolated confinement.

These cracks in Oakeshott's idea threaten to widen into a fork in the road for those of us pursuing his vision. We could insist on pure freedom and radically qualify the possibility of liberal learning, finding in such learning practical roles

to assume or feats of self-mythologizing to celebrate, but nothing like a defining self-understanding. Or we could insist on the possibility of liberal learning with its potential to disclose who we really are, and radically qualify our freedom by restricting it to the quest for authenticity, for the true self we are already determined to be irrespective of our understanding. Ironist or Oedipus: neither alternative, it would seem, leaves the union of freedom and learning intact. Can we restore it?

QUESTIONABLE EXISTENCE

Perhaps we need to turn around and reexamine Oakeshott's first principle, namely, the priority of freedom, of the capacity for understanding, to anything that is the product of understanding. Is this truly bedrock, or could there be still another principle underneath?

The reason I think there is something yet more fundamental is that Oakeshott locates the conditions of understanding one-sidedly in us, the subjects of understanding. He traces the impulse to understand to a capacity that we possess: our freedom. Yet is it not more plausible to think that understanding is also radically conditioned by the nature of its objects? I sympathize with Oakeshott's mistrust of any vulgar Darwinism that would reduce understanding to adaptation or socialization; I agree that it is truer to our experience, even if it leaves explanation lacking, to consider adaptation a product of understanding. But there may be another way that understanding is called for by the things and world to be understood without being causally determined by them. I use the loose term "called for" because I want to preserve Oakeshott's convincing stress on freedom; I want to emphasize too, however, that understanding should be considered a response and not a purely spontaneous impulse.

Readers of Martin Heidegger will recognize this appeal: "We must before all else incline toward what addresses itself to thought—and that is that which of itself gives food for thought."[20] But where he strikes out on an ambitious path of what he calls "Thinking," one step may be enough for my purposes. Let me venture that understanding grows out of both its subject and its object. It is *equally* nourished by individuals by virtue of their freedom *and* by things and their world by virtue of their questionableness. I can understand because I am free—and because the world is such that it elicits understanding. It is questionable: the world draws out my understanding of it by raising the question of what is to be understood by it and by addressing that question to me.

Why is this? A commonsensical answer is that as we act in specific circumstances, we find ourselves unexpectedly impeded, and this provokes a puzzlement that we articulate as specific questions. This kind of explanation, however, once again reduces questionableness, and the understanding elicited by it, to a moment in a process of adaptation that simply is what it is. Questionableness is considered an *effect* of a world that is at bottom, supposedly, self-evident.[21] In contrast, just as Oakeshott argues that we are free before we are, or do,

anything in particular, we may wonder whether there is a way of conceiving of the world as being questionable *before* it is a matter of particular questions in the (unquestioned) context of a practical project. A key would be if we could identify some feature of the world that is always present in every state of affairs, and that is always questionable. This would open the door to speculation that irrespective of any project we are involved in, or indeed prior to being engaged by any project at all, something about the first dawn of consciousness already calls for our understanding—a call that reverberates diurnally.

"It is not *how* things are in the world that is mystical, but *that* it exists."[22] Suppose we substitute in this aphorism of Ludwig Wittgenstein's "fundamentally questionable" for "mystical." Questions naturally arise all the time about all sorts of things, but most of these questions, as I observed, are relative to specific projects and circumstances: today we may wonder about life on Mars, but tomorrow we may be too busy with other things to care, or we may already possess the relevant facts. But why does the "world," which Wittgenstein defines as "all that is the case," exist?[23] Is it possible for everything not to exist, particularly before and after my consciousness does? No answer, no conceivable description of how things are *in* the world, would avoid begging these absolute questions. Moreover, they evoke our mortality, about which it is hard to imagine us ceasing to care. These questions, thus, are always pertinent, always addressed personally to each of us.

Let me call the fact that everything exists (whatever sort of things that turns out to include) "existence." Existence is questionable: it calls us to exercise our freedom, to understand its meaning for us. Is there truly no reason for existence or for why I exist? Why should I go on, in any fashion, if the world might as well not? We can each try to respond to this knot of questions or to ignore it.

Finding ourselves addressed by these questions, we are in a position to dispel one of the riddles of Oakeshott's exclusively freedom-based understanding. Instead of puzzling over how we could be condemned to be free, we can now more clearly understand our freedom as something that is not the result of a process or event of determination at all. It may be possible to describe our behavior in such positivist terms. If we want to include in that description human understanding, though, we need to acknowledge a free realm of the individual that is unaffected by physical causes. And if we in turn wonder how this realm came to be, we could speculate that it was called for by existence that is not causal but questionable. Existence could be the profounder foundation, the true first principle, of liberal learning and the exercise of free understanding.

I noted above, however, that the questionableness of existence brooks no answers. For that reason, we may be tempted to ignore it in the same way that Richard Rorty shrugs off Immanuel Kant's thing-in-itself; he dismisses it as "an utterly useless notion, the plaything of philosophical skeptics, a toy rather than a tool."[24] Certainly, if freedom unconstructively undermines self-understanding, as I feared earlier, then existence would seem to do so even

more radically. How can an abyssal questionableness mean anything for who I am? Is it not rather the kind of skepticism we typically experience in identity crises? Liberal learning of any sort would appear to be the last thing this would yield.

Suppose, though, I were to respond to questionable existence by acknowledging, contemplatively, how it is implied by the other beliefs that guide my life. Each conception I have of how things are in the world, particularly those pertinent to my desires and hopes, implies the world's existence. Indeed, apart from identifying some particular thing as the root of a chestnut tree, to allude to the central scene of Sartre's *Nausea*, I may always remark on the prior fact that whatever it is (called), it exists.[25] From concern about a specific state of affairs—for instance, about whether my love for someone is reciprocated—then, I could always articulate a link to this fundamental concern about the world's being. When things face me with a question, my energies could go, not into answering it, but into sharpening and deepening it so that its metonymical relation to this questionableness stands out more trenchantly. As a result, it would start to appear less rooted in contingent circumstances than in necessary existence: I could understand my worry about being loved as an echo of my existential uncertainty. My response to this worry, accordingly, could also be a response to this necessity. This acknowledgment of existence would thus be eminently philosophical in that it seeks both to place parts of life in relation to a sense of the whole, and to interrogate the assumptions of common sense. However, what this acknowledgment would not do is attempt to answer or invalidate the world's questionableness. Although I remain free to ignore the latter, I would choose otherwise.

What could be the reason for this choice? Clearly, it is not some simple desire to preserve myself: questionable or not, my continued existence depends on solving as intelligently as I can problems that threaten my welfare. But suppose I were also interested in understanding, in savoring, and ultimately in celebrating what it is like to exist: the subjective experience of existence.[26] Would not this inquiry into how other experiences of mine evoke this one contribute to such an understanding? And would not experiments in tackling problems that address too the higher mystery—that *live* that mystery—also contribute to that understanding? A reason for acknowledging questionable existence rather than denying it would be my sense that I am most authentically myself when I experience existence—existence that is not restricted to any particular state of affairs—consciously. This is what makes me, a creature of changing circumstances, also *human*. Understanding how the different moments of my life all lead back to this experience and may advance coherently from it would thus be a form of liberal learning. I would be my understanding and my learning in question.

It might seem odd, if not perversely alienating, to identify the experience of existence with the self of liberal learning. Yet this self-understanding has the merit of permitting me to absorb fully Sartre's insight into bad faith and

at the same time to elucidate his notion of authenticity. Instead of considering bad faith an error that needs to be corrected, as his formulation suggests, I am now in a position to appreciate and redescribe it as a truth of our common condition—as, indeed, the proper object of authentic self-understanding. To realize that I am necessarily in "bad faith" *is* to realize that I exist. Who am I? is not a question that can be answered by trying to define myself or to distinguish my true from apparent selves; such answers mistake for something inherent one or another role that I freely take up, and may lay aside, for certain purposes and people. Obviously, my society may lock me insuperably into some such role, or I may grow habitually attached to it, but I will always possess the inner freedom, if not the courage or practical opportunity, to disown its recognition. The question of identity is better interpreted, therefore, as a skeptical reminder that, as Wittgenstein put it, the naked self is "the limit of the world—not a part of it."[27] I would gloss this as saying that my sense of selfhood is my feeling both that the world, that life, is essentially a limited, mortal whole whose existence is questionable, and that it is mine because I must take responsibility for the meaning of my free responses to this questionableness. Moreover, the self is not something *in* the world. I shall return to these points in the next chapter when I discuss Sartre's theory of consciousness. For now, let me simply remark that my project above of taking responsibility, of questing for authenticity, becomes, then, not one to understand what it means to be this particular person or a member of this community; it renounces the quest for identity. Rather, it seeks what it means simply to be. Indeed, departing a bit from Sartre, I would stress the continuity between authenticity and our essential, lifelong learning rather than equate authenticity too narrowly with the willful moment of decision, when we each alone leap into the unknown. The authentic self is not isolated but in conversation.

How should I live concretely with this sense of existence? Hopefully, the speculation of the last few paragraphs has made this a compelling enough question for others as well as myself and an invitation to a distinctive kind of learning. There are many paths to and from this question and many ways of raising and responding to it. Some philosophical and artistic works show how wanderlust broaches the experience of existence, others how this experience can provoke violence or laughter or can revive political solidarity. Some mourn in the experience the death of God; others find in it in the eyes of a child. For instance, in Wim Wenders's film *Alice in the Cities* (1974), the protagonist, Philip, comes to terms with existence when he gives himself over to young Alice's search for family. Such diverse, nondefinitive, and controversial works teach us how to cultivate individual ways of existing authentically. They show us that the question has no answer, only answers. This diversity is possible, however, only because questionable existence, present at all times and places, is a universal concern. About this topic, people from radically different societies may talk to, and learn from, each other, as I have learned about this possibility in conversation with Oakeshott and Sartre.

Am I promoting some kind of singular, all-assimilating culture? Am I not, for the umpteenth time, cloaking Western interests in the idea of existence—and in other, more dubious things that have historically accompanied this idea—inside a universal claim? No promise of learning should make us forget the harsh lessons informing this suspicion. But the culture of existential learning I am evoking is not at all meant to be an exclusive one, and I do not see any necessary reason why it must eventuate in some such culture. Of course, we are divided into numerous communities and cultures so that the better part of wisdom is to find ways to accommodate this diversity while working on the conflicts, rather than forcing us into some(one's) ideal unity. For that reason, I gladly admit that my culture will remain one among many for the foreseeable future. Nevertheless, this counsel of realism need not foreclose efforts to broaden cultures so that they bring as many people together as possible and thereby diminish antagonism. Our historical cultures are not set in stone. A culture of existential learning—one that members of other cultures may participate in and one that some of them may come to recognize as their central culture—promises to place our differences in relation to the shared fact of being. Is that not a pacifying prospect?

Even if this culture manages to expand its membership and influence, though, it would not, strictly speaking, progress. The conversation of existential learning cannot claim to be a science. To hope that the next thinker coming over the horizon will lift us finally out of our ignorance or to presume that he or she could once and for all bury our precursors is to profoundly misunderstand the nature of this conversation. At the core of someone like Aristotle, at least in this context, is not his falsifiable astronomical beliefs but his general attitude toward existence. The fact that he may be wrong about the heavens or that Dostoevsky may be a dubious guide to nineteenth-century Russian society does not automatically discredit them: it may very well be that their overarching sensibilities can be reconciled with the corrected facts. Nor should such factual errors automatically save us from the challenge their attitudes pose to our own. For the sake of our existential learning, it cannot be said too strongly: condescension to the past is a form of intellectual cowardice we should rise above.

Freedom is truly the root of our learning humanity. But germinating and nourishing that root, and all that stems from it, is the soil of existence. When we view our freedom as the way we experience, or are addressed by, the questionable, we can see that it is more than a negative freedom. It is the freedom to acknowledge, rather than deny, what calls for understanding and to learn how to do this. Existential learning discloses who we are by illuminating what it is like to exist.

This chapter has offered a brief, theoretical reinforcement and redescription of Oakeshott's idea of liberal learning. I have tried to dispel doubts about the point of this noninstrumental learning and clarify its aims by grounding the learning on an appreciation of not only our freedom but also our existence. This lays the cornerstone of a philosophy of a revised form of liberal education—but

of course I need to establish more fully that this philosophy can support and be supported by concrete practices. In particular, the burden is on me to explicate the sort of teaching proper to this learning. What might the appreciation of existence actually look like, such that it connects someone's familiar experiences to his or her perennially unfamiliar, authentic self? What kinds of pedagogical works might stimulate such an appreciation? In the remainder of this book, I shall be building an argument that the culture of modernism provides us with a rich source of such works and with models of self-understanding. It is by no means the only source—think of how existential anxiety is pondered in Shakespeare's tragedies—but it is an especially extensive one. Some of the principal features that have traditionally defined a work as modernist also suit it for cultivating existential learning. We will start to see this in the next chapter, where we turn to Clement Greenberg's idea that this work characteristically stresses the medium of its art. He finds in this stress a securing of the artwork's autonomy, but I hope to show otherwise. It represents a way of honestly acknowledging the being foreign to our control.

CHAPTER THREE

Strangerhood

In my call for existential learning, I broached the possibility of moving from an experience of a problematic situation to that of questionable existence. Instead of immediately trying to solve the problem, one would pause to see in it a reflection of the questionable nature of everything that is. The problem would thus serve as an occasion to return to an experience in which, I suggest, one is most authentically oneself: a being aware of its existence. Now such awareness is apt to sound laughably trivial—when one forgets how deeply in question this awareness leaves one. It also sounds like a contemplative indulgence next to the pressure to come up with solutions. To help someone engage in existential learning, then, we would need to draw that person back to this experience of existence in a way that overcomes resistance to its vertiginous skepticism and patent impracticality.

Modernist works are tailor-made to do just this. In this chapter, I want to focus on how such works suspend practical concerns, to a degree, by compelling us with the force of a kind of necessity. (Chapter 4 will take up the issue of skepticism.) They insist on the priority of existence. How? The answer lies in Greenberg's account of the modernist medium, and particularly in Clark's revision of that account. Clark argues that modernist works expose the medium to scrutiny by negating certain of its traditional features; this action reflects the absence of an audience for the work. I agree with this interpretation as far as it goes, but I want to claim that something else gets represented by this act of negation as well, as if in setting out to register a cultural predicament these artists stumbled on our existential one. To explain this, I shall develop an analogy between Clark's theory of the medium and Sartre's of consciousness. The modernist medium, marked by negation, like our consciousness in general, generated by "nihilation," discloses the inescapably questionable scene of existential learning. The medium is thus no longer an object of simply formalist interest, marveling at the composition of its elements. It conveys a philosophical anthropology, an understanding of what sort of beings we fundamentally are. From whatever world may be positively represented as the

subject matter of modernist works of art and literature, the medium brings us home to our strangerhood.

MEDIUM AND NEGATION

Clark's history of the origins of modernism, which I summarized in chapter 1, recounts how the traditional high culture of the West was increasingly abandoned by the bourgeoisie in the nineteenth century. In consequence, this meant that although the former's artworks and literary works endured, and like ones continued to be created, they were no longer so distinguishable from works of decoration, propaganda, or entertainment. Ancient and medieval styles of kitsch made a killing, as academic formulas lent themselves to mechanical reproduction. Reacting to this, modernists put forward an art that would renounce commercially and ideologically exploitable effects. They wanted to preserve traditional, challenging, aesthetic value in forms that would stay at least a step ahead of their flattering simulations. We left the story at the point, as Clark indicated, where the most promising strategy for accomplishing this, according to Greenberg, appeared to be that of stressing the artwork's medium. "In turning his attention away from subject-matter or common experience, the [modernist] poet or artist turns it upon the medium of his own craft."[1]

The foregoing starts to account for why this takes place, but what exactly does this turn entail? Clearly, Greenberg in "Avant-Garde and Kitsch" has in mind a particular kind of artistic and literary approach.

> The non-representational or "abstract," if it is to have aesthetic validity, cannot be arbitrary and accidental, but must stem from obedience to some worthy constraint or original. This constraint, once the world of common, extraverted experience has been renounced, can only be found in the very processes or disciplines by which art and literature have already imitated the former. These themselves become the subject matter of art and literature. If, to continue with Aristotle, all art and literature are imitation, then what we have here is the imitation of imitating.[2]

Previously, the features of Western art were evidently necessitated, ruled, by the project of representing and communicating familiar subject matter. We all know what it means to call a sculpture "lifelike" or a novel "naturalistic." Abstraction, in contrast, is signaled by the appearance of features that float free of this project, provoking in us a basic perplexity. How should we understand these marks, or what the work as a whole is about? There is an impulse to dismiss such works as lawless, gratuitous, and so invalid because they are incapable of rewarding and sustaining serious attention to their features. To dispel this suspicion, the work needs to demonstrate a scrupulous responsiveness to "some worthy constraint or original." At a time when the definition

and significance of much subject matter was becoming tangled up with its commercial or propagandistic potential, a more intransigent, inherently aesthetic constraint announces itself in the work's medium, more specifically, in its capability of presenting any subject matter at all. What can this medium truly reveal? What are its limits?

Answers to these questions, Greenberg finds, become the new subject matter of the modernist work; such work is less nonrepresentational than self-representational. It displays what its medium can and cannot do; it puts the medium to work on a set of forms in a way that illuminates the medium's properties beautifully. Accordingly, while a painting, for example, may seem on cursory glance to be about the commonplace world in an extremely distorted or puzzling fashion—about, say, a glass of absinthe on a table viewed through a prism, or scattered drips of paint—it is more meaningfully about how the medium organizes the work's features. Picasso's analytic cubism shows how insistent acknowledgment in the image of the painting's rectangular plane can translate the distinct figures of a traditional still life into a single, ambiguous space of jagged and transparent recessions and protrusions, a space capable of gratifying sustained attention. And Jackson Pollock demonstrates that line liberated from shape can still function as a vehicle of pictorial beauty.

The aim of this self-reflexive probing, as Greenberg notes in a famous passage from "Modernist Painting," is akin to that of Kantian self-criticism. Modernist works seek to get in touch with each art's proper scruples, its integrity: "The essence of Modernism lies, as I see it, in the use of characteristic methods of a discipline to criticize the discipline itself, not in order to subvert it but in order to entrench it more firmly in its area of competence. Kant used logic to establish the limits of logic, and while he withdrew much from its old jurisdiction, logic was left all the more secure in what there remained to it."[3] In a situation where the arts are in danger of being taken for a bag of rhetorical tricks to be used as one will, modernism constitutes a project of proving that the former contain, in their mediums, properties that have an intrinsic link to aesthetic quality and so demand respect. By registering care for its medium's genuine aesthetic possibilities in the features of a work, the modernist makes the work responsive to its own constraints rather than external considerations. Such considerations enlist the work in the business of propagating illusion; modernist art on the contrary is anti-illusionist. Indeed, this scruple constitutes a law that takes precedence over any other opportunistic goals or hypothetical imperatives of which art and literature may be put in the service.

Furthermore, not only are these qualities of a particular art predicated on a demotion of instrumental ones, they are properly distinct as well from those of the other arts. Reinforcing the front against kitsch entails maintaining the borders of each art; painterly possibilities must not be confused with literary or musical ones. Dance is not theater. Modernists sought to refound, as it were, each artistic medium by identifying what is essential to it and separating that from

what is foreign and corrupting: "The task of self-criticism became to eliminate from the specific effects of each art any and every effect that might conceivably be borrowed from or by the medium of any other art. Thus would each art be rendered 'pure' and in its 'purity' find the guarantee of its standards of quality as well as of its independence. 'Purity' meant self-definition, and the enterprise of self-criticism in the arts became one of self-definition with a vengeance."[4] The elements of abstract work demonstrate that each artistic medium sets definite conditions for any work that claims aesthetic quality in it: individual poems, for example, must be subject to the rules that make poetry in general possible. Successful modernist work demonstrates this movingly. Accordingly, John Ashbery's lyric, "Worsening Situation," does not so much describe the situation as take us through an experience of one; it stimulates worsening disorientation simply by stressing the disruption inherent in a medium that relentlessly breaks utterance into lines. The medium in works like this thus serves as a site of self-rediscovery and purification, where the modernist arts, so to speak, reflect on their specific, innate principles and claim the self, with its capacity for beauty and pathos, defined by those principles. "I acknowledge my medium, therefore I am": such a pure art personified would be on guard against involvements that compromise its autonomy. The principles of its medium become its artistic conscience.

Now for every person who finds such disclosures of moral conditions and identity beautiful, there are plenty who have been evidently underwhelmed by their involuted technicality. Even if we concur that the threats to the autonomy of the arts are serious, we may worry that the modernist response is liable to backfire, as the decline of modernism suggests it has. Its austere necessities, far from recalling us to our aesthetic commitments, might have driven many that much more determinedly to nonmodernist art and entertainment, in search of the warm, accessible sympathy we treasure in the old masters. Perhaps postmodernism represents a sloping away from the chilliness of all that art about art, resignifying the modernist look as druggy intensity or funhouse kicks, or, more generally, glamorous cool, something in any case less forbiddingly difficult. Modernism was soon dogged by the suspicion that it was an art for artists and aesthetes only, and so irrelevant to the person on the street if not offensively elitist.

Clark builds on this critical perception that modernism lacks audience appeal, but disabuses it of any notion that the fault lies with the masses being either unable or indisposed to appreciate purely aesthetic values. Such values are beside the point. In "Clement Greenberg's Theory of Art," he agrees that modernism is mediumism. He is struck, however, by the fact that Greenberg's account of the stress on medium seems out of touch with this stress's inevitable rhetorical charge. "How does the medium most often *appear* in modernist art?"[5] Not as an affirmation of aesthetic integrity; in the visual arts, for example, before purification comes into view we see something else that disturbingly overshadows it. He observes that the "medium has appeared most characteristically as a site of negation and estrangement."[6]

Why negation? The reason is historical. "Realistic, naturalistic art had dissembled the medium, using art to conceal art; Modernism used art to call attention to art."[7] As Greenberg notes in this passage, Western artists traditionally demonstrated command of their mediums by, among other accomplishments, rendering these mediums invisible so that their works appeared to give one immediate purchase on some part of the world. A whole set of practices and norms consolidated this achievement and thus formed each medium. Painting, for instance, largely consists of just those means for creating illusory, lifelike depth on a two-dimensional surface. To draw attention to the medium, therefore, is to push against the grain of its historical, constitutive achievements; paradoxically, the more painterly the painting, the less like a traditional painting it is. Hence to make the medium appear is to pervert, to negate, its conventional functions.

Of course, Greenberg is perfectly cognizant of this. However, he considers this negative dimension of the act of disclosing medium a mere moment on the way to an affirmation of the medium's principles. In the process, an art may lose some of its old offices along with newfangled exploitations of those—but it thereby gains its soul. The shock of the unfamiliar and the rebellion against academic maxims and kitsch fashions may give these works a negative cast, but that is hardly the point of modernism. The proof is in the overriding aspiration to beauty still evinced by most of its works. Whatever else Helen Frankenthaler's *Mountains and Sea* is trying to do with its unusual, brushless stain technique, it surely intends to be gorgeous. In line with this, Greenberg was consistently hostile in his appraisal of anything that smacked of what he later dubbed antiart "avant-gardism."[8] The famous *Fountain*, which Marcel Duchamp created when he signed a urinal "R. Mutt" and entered it in The Big Show art exhibition of 1917, is to Greenberg's eyes nothing but a sardonic prank; ditto for Andy Warhol's *Brillo Box*.[9] Such works and their spawn simply make explicit the implicit nihilism of kitsch; they ought to be denounced as a kind of modernist fifth column.

It is on this restricted role that Greenberg gives to negation in the stress on medium that Clark focuses his criticism.

> I think that finally my differences with Greenberg centre on this one. I do not believe that the practices of negation which Greenberg seeks to declare mere *noise* on the modernist message can be thus demoted. They are simply inseparable from the work of self-definition which he takes to be central . . . Modernism is certainly that art which insists on its medium and says that meaning can henceforth only be found in *practice*. But the practice in question is extraordinary and desperate: it presents itself as a work of interminable and absolute decomposition, a work which is always pushing "medium" to its limits—to its ending—to the point where it breaks or evaporates or turns back into mere unworked material. That is the form in which medium is retrieved or reinvented: the fact of Art, in modernism, *is* the fact of negation.[10]

More strongly than any affirmation of some positive essence, the modernist work registers the will to refuse the conventional inheritance; this is a central and irreducible part of its meaning. That art should negate its traditional elements, commit suicide, rather than allow itself to be enslaved or degraded, is the moral of modernism: dada's Cabaret Voltaire, not André Malraux's Imaginary Museum, is its true destiny. One may still desire beauty, of course, but that desire and its satisfactions cannot be purely celebratory; its taste will have something sour and acerbic, or fragile and futile. In every "experimental" departure will be a whiff of punk. Moreover, this negation, even at its extreme, is bound to appear incomplete and in principle interminable; in order to register the negation of some conventions, other conventions, equally suspect, have to be at least temporarily employed. Under this view, modernism proceeds according to the same unstoppable logic as philosophical skepticism, constantly turning on itself.

Clark's interpretation of the stress on medium has all the bleakness of a Samuel Beckett piece. What accounts for this "extraordinary and desperate" practice is once more the crisis of nineteenth century bourgeois culture; it is the art of this historical period that is discovered to possess this negative nature. Although Greenberg appreciated the gravity of this crisis, he held out hope it could be surmounted if the arts were to reaffirm the integrity of their mediums. Clark detects in the putative products of such hope a darker, more moving undercurrent. Even if and when modernism seeks to reassure itself, negation is how it irrepressibly registers its hurt and anger. And disenchantment.

Indeed, modernism's tropism to negation is a perfectly understandable response to the prior negation of its claim to inherit traditional high culture by the majority of its class. Its flight from familiar artistic practices echoes, belatedly, the departure of an audience who truly cares about those practices. This is why Clark calls the medium a place of estrangement. "Pushing medium to its limits" makes for strange artworks, as we all know, and Clark suggests that the evident relish for the bizarre on the part of modernists is no accident, no mere byproduct. Like the central character of Thomas Mann's short story "Tonio Kröger," modernism in general appears to be trying to will its imposed alienation, expressing a fundamental ambivalence toward its proper but unfaithful, bourgeois audience, its philistine mate. No wonder its acts of negation end up being interminable. They can hardly be effectual in wooing back an audience that has a vested interest in losing interest in aesthetic, not to mention other, scruples. Modernists must therefore be content with representing to themselves alone the crisis of their culture and their consequent marginality—with taking pride in their ghettoization. "Negation is the sign of this wider decomposition: it is an attempt to capture the lack of consistent and repeatable meanings in the culture—to capture the lack and make it over into form."[11] This form testifies to the artist's exile from his or her society.

For this reason, what is ultimately at issue in modernism are not aesthetic value and purity, but a whole social order that has no function for genuine art.

Modernism is trapped between the indifference of the audience it seeks and its artists' and supporters' siege mentality. Clark plausibly concludes that it cannot survive in this predicament; its only hope is to find another sustaining audience beyond its enclave. He suggests it follow a certain prophet's lead.

> There is an art—Brecht's is only the most doctrinaire example—which says that we live not simply in a period of cultural decline, when meanings have become muddy and stale, but rather in a period when one set of meanings—those of the cultivated classes—is fitfully contested by those who stand to gain from their collapse. There is a difference, in other words, between Alexandrianism and class struggle. . . . The end of [the bourgeoisie's] art . . . will involve, and has involved, the kinds of inward turning that Greenberg has described so compellingly. But it will also involve—and has involved, as part of the practice of modernism—a search for another place in the social order.[12]

The old dream of a proletarian modernism: given the history we have been working with, it does have a certain appeal. Perhaps the only way to reform our culture really is to revolutionize our social order. However, while a militant art or literature aimed at a working-class audience makes sense as a response to the crisis of bourgeois culture, it is hard to see why that art should be modernist. Stressing the medium, even understood as subjecting traditional conventions to negation, would appear to be risibly beside the point if the goal is not to *épater les bourgeois* and in the act bring them to their senses, but to reach and agitate others who have never been given much opportunity or reason to give a damn about those conventions. Why should not such an audience be completely cold to any preoccupation with form, preferring to build straightforwardly on the experiences registered in its own folk cultures? The disappointing unpopularity of the films of the early Soviet director Dziga Vertov, and of the French *Groupe Dziga Vertov* born of May '68, appears to bear this out. Clark believes that the decline of bourgeois culture could pave the way for another culture to prevail. But in this scenario, there would be little reason for that culture to be modernist.

I wonder if there is a way of holding on to modernism, its achievements and promise as portrayed by Greenberg, while pursuing Clark's suggestion that it redefine its audience. What prompted the latter was the evident emphasis that modernism puts on negation. This emphasis, though, may have deeper roots than class conflict. Perhaps it is responding to, and representing, a feature of our universal nature that is nonetheless also, in a different way, political. This, at any rate, is the hunch I would like to pursue by developing a Sartrean interpretation of the modernist medium.

CONSCIOUSNESS AND NIHILATION

It might seem odd to bring Sartre into this discussion since neither modern-ism nor the nature of artistic mediums were central concerns of his. Recollect, though, the understanding of medium with which we have been working, particularly its role in artistic signification. A medium operates as an interface between the artist who presumably wants to represent, signify, something and an audience who will hopefully recognize those signifiers. The medium makes it possible for those signifiers to appear and function and in the process, it subjects these to certain conditions. Normally, the medium and its conditions withdraw into concealment, to employ a Heideggerian trope, in order to present the signifiers, and much more prominently the world they signify, immediately. Think of the medium as the roadies; the signifiers, the band; the world signi-fied, the music. Modernism, however, demonstrates how we may spotlight the medium by negating this fictive immediacy, familiarity, of the signifiers, rendering them somewhat cryptic. Why is there a green stripe running down the middle of Madame Matisse's face in the famous portrait done of her by her spouse in 1905, violating lifelikeness? How does that weird signifier of a shadow draw attention to the tense, delicious balance between the painting's color fields? Signifier, conditions of appearance, negation, estrangement: these are the central terms of our elaborated account of how the medium operates. Almost all of them recur in the theory of consciousness propounded in Sartre's early magnum opus, *Being and Nothingness*.

That book is subtitled *An Essay on Phenomenological Ontology*. Sartre evidently means to inquire into the phenomenal nature of whatever in general appears, setting aside questions of whether particular appearances represent truly or falsely objective states of affairs. More specifically, with regard to this realm of phenomena, presumably the most primitive building blocks of experience, he is interested in what kinds of beings there are in it. What exactly are phenomena; does their existence imply the existence of any nonphenomenal beings? According to Sartre, for phenomena to exist, they must exist for a consciousness that is not itself a phenomenon. The words on this computer screen are appearing to me, but I, in my strict capacity as the consciousness of these words, do not appear at all with the words. In parallel fashion, phenomena also entail the existence of something besides me that transcends consciousness and appearance and so again is not a phenomenon. I can only be conscious of words on a screen that ultimately reside outside my consciousness and what appears in it. Thus from the existence of phenomena, we can derive the existence of two other kinds of beings: consciousness and things in themselves beyond consciousness.

Having arrived at this dualistic ontology ("being-for-itself" and "being-in-itself"), Sartre proceeds to describe more fully how these two kinds of being interact so that appearance can take place; in effect, he derives the being of

the phenomenon from this interaction. Figuratively speaking, consciousness is a movement reaching outside itself to make contact with something, such as a table: "All consciousness is positional in that it transcends itself in order to reach an object, and exhausts itself in this same positing. All that there is of intention in my actual consciousness is directed toward the outside, toward the table; all my judgments or practical activities, all my present inclinations transcend themselves; they aim at the table and are absorbed in it."[13] This intentionality anchors consciousness, as remarked above, in an object separate and different from it: "Consciousness is consciousness *of* something. This means that transcendence is the constitutive structure of consciousness; that is, that consciousness is born *supported by* a being which is not itself. . . . Consciousness implies in its being a non-conscious and transphenomenal being. . . . To say that consciousness is consciousness of something is to say that it must produce itself as a revealed-revelation of a being which is not it and which gives itself as already existing when consciousness reveals it."[14] Meanwhile, in addition to reaching outside itself, consciousness simultaneously apprehends itself: it is conscious that it is conscious; its revelation is revealed in a possessive, yet undefined and nonobjective fashion that Sartre calls "prereflective." In the example below, I become conscious not only of a number of cigarettes but of *my* consciousness of this. However, because consciousness is completely transparent to its objects, as it were, its consciousness of itself remains akin to merely a vague sense of self-possession. Consciousness cannot clearly and distinctly objectify itself.

> Every positional consciousness of an object is at the same time a non-positional consciousness of itself. If I count the cigarettes which are in that case, I have the impression of disclosing an objective property of this collection of cigarettes: *they are a dozen.* . . . It is very possible that I have no positional consciousness of counting them. Then I do not know myself as counting. . . . Yet at the moment when these cigarettes are revealed to me as a dozen, I have a non-thetic consciousness of my adding activity. If anyone questioned me, indeed, if anyone should ask, "What are you doing there?" I should reply at once, "I am counting." . . . Thus in order to count, it is necessary to be conscious of counting.[15]

Obviously, I am severely abbreviating and schematizing Sartre's thinking here. What I nevertheless hope is emerging is an explanation of how the workings of consciousness, with its intentional interplay between two modes of being and its possessive grasp of itself, make phenomena possible. On the basis of such phenomena, projects for specific people start to take shape, requiring these actors to make judgments: thus begins the process of understanding at the root, as Oakeshott established, of our humanity.

So far, my discussion has touched on the central terms in the title of Sartre's book save one: nothingness. This last comes into play when we consider

the question of which features of the nonconscious would be registered by the conscious as the predominant ones. Given his ontology, we would expect that more than the details of the object—its size, color, historical significance, and so on—the sharp difference between its and consciousness's very modes of being would make a deep impression. I would be conscious above all of the ontological difference between the words on the screen and myself. Sartre does follow this line of thinking, but complicates it by noting that "difference" is a concept that is always relative; it has no meaning outside a world already formed by comparisons, by a comparing consciousness. How then can consciousness encounter the difference of the nonconscious if difference can come into play only after consciousness has registered a state of affairs in the world? Moreover, difference depends on an even more elementary concept: negation. Negation accompanies human beings like a shadow; without people capable of registering that something is not something else, or that something is lacking, there would only be various states of affairs without any comparative significance. Yet unlike difference, negation is not simply a tool I employ to bring order to a world after I have become conscious of it; my negative judgments are based on instances where I become conscious of something's distinct and palpable nonbeing, of its nothingness. I learn what nothingness feels like, for example, when I rush to the café to meet Pierre and discover he *is not* there.[16] So our question boils down to: How does one become conscious of the fundamental fact that the object of consciousness *is not* one's consciousness, and that between consciousness and its object there is nothingness?

Sartre's answer goes in the only direction open to it. Because nothingness does not exist in the nonconscious world, it must be carried into it by consciousness itself. The latter's reaching toward its object must be equivalent to a negating of identification with it that produces nothingness. Sartre calls this process nihilation and our conscious being is its fuel.

> There must exist a Being (this cannot be the In-itself) of which the property is to nihilate Nothingness, to support it in its being, to sustain it perpetually in its very existence, *a being by which nothingness comes to things*. . . . It would be inconceivable that a Being which is full positivity should maintain and create outside itself a Nothingness or transcendent being, for there would be nothing in Being by which Being could surpass itself toward Non-Being. The Being by which Nothingness arrives in the world must nihilate . . . Nothingness in its being *in connection with its own being*. The Being by which Nothingness arrives in the world is being such that in its Being, the Nothingness of its Being is in question. *The being by which Nothingness comes to the world must be its own Nothingness.*[17]

Words appear on a screen: this phenomenon may be described ontologically as my consciousness of not being those nonconscious words. As I look from them to other things, for example, the Empire State Building outside my window,

my consciousness nihilates those in turn; it runs through the world like some
insatiable force of not-being, never encountering what it is. I am not this and
I am not that. Indeed, when I consider my own past and the future I am trying
to become, I realize that I can only be those things by also not being them, by
being separated from them by my very consciousness and nihilation of them.
Yet all along, my consciousness apprehends itself prereflectively as precisely my
own nothingness. This, we know, is for Sartre our anguished freedom. Such an
understanding of our conscious being recalls Wittgenstein's conception of the
self as residing not in, but at the limit of, one's world.

How is consciousness like an artistic medium? Sartre illuminates some
intriguing parallels. Like the medium, consciousness enables things to appear
by subjecting them to the conditions of a certain process. According to these
ontological conditions, beings, or objects of consciousness, may appear—only
as not being consciousness, which is itself no being but someone's nothingness,
in the train of reaching beyond itself. We can thus think of consciousness as a
medium interfacing being and nothingness.

It departs in two ways, though, from our notion of the artistic medium.
First, what appear in consciousness are not signifiers or representations but
phenomena. The object of consciousness need not be anything recognizable, let
alone anything referring to something recognizable; it need only be (whatever
it is). A second departure has to do with the role of negation. In modernism,
negation is what causes the medium to appear; the medium could function, and
traditionally has functioned, without negation. In Sartre's theory, the medium of
consciousness essentially *is* determinate negation. Do these differences between
consciousness and artistic mediums, then, vitiate the possibility of drawing a
viable analogy between them?

Not if we can place these differences within an overall account of why the
analogy is meaningful. To build to this, let me review the interplay between
signification and negation in modernist art. In its works, signifiers appear; what
are they of? According to Greenberg, they are not only of things or events in
the world but they also, principally, refer to the work's medium that allows the
signifiers to appear in the first place. The figure in Èdouard Manet's *The Fifer*,
to pick a canonical example, refers not only to the eponymous person but also
to that person's signification in a medium with notable conditions, in this case
flatness. Clark would point out that in order to refer to its conditions of refer-
ence in this way, however, the painting has to reject its medium's traditional
projection of depth and, by extension, its figure's conventional verisimilitude.
The figure depicts not just a fifer, and not just flatness, but a specific negation
of perspective painting and fifer-likeness. So what, as a result, do we see when
we look at *The Fifer*? We see a figure, in a particular medium and conditioned
by its rules, *not being a fifer*. A figure of Sartrean consciousness.

We see ourselves.

I mean this quite literally. The features of the painting that expose its medium show that the figure is expressly not some determinate thing, a fifer. The signifier signifies that it is a signifier and not what it signifies; to disclose characteristics of the medium, in this semiological sense, is to disclose the specific nature of the gap, the *non sequitur*, between signifier and signified in works of this art form. Although René Magritte's painting *Ceci n'est pas un pipe* (this is not a pipe) is hardly the most subtle work, it does formulate a central moral of the stress on medium. Now what I am proposing is that we move from this semiological understanding of the painting's central figure to a more experiential one in terms of consciousness. Instead of remarking on how the figure of the pipe, the signifier, is not the pipe that is signified, we may remark on how the figure, the object of consciousness, is not our consciousness of it. Likewise, the figure that is not a fifer aptly depicts the state of not being the fifer; it depicts someone's, say, my, consciousness of the fifer. According to Sartre, I am at bottom my consciousness. Thus the figure that is specifically not a fifer, not to mention anything else, this figure of intentional nonbeing, is an image of me. Not of my body, obviously, but of my fundamental nothingness.

How strange an image! But it is actually fitting. It *reflects*, in the unnatural features of the fifer figure, a being that is not a particular thing. All I know of it is what it is not, something familiar. When I generalize from this to other modernist images, I grasp that the modernist mirror can only tell me who is the most *unheimlich* of them all: the one who can be glimpsed uncannily shadowing everything in the world yet who can never be identified with any of them, the ubiquitous one free of identity. [18]

Now even if we find this Sartrean interpretation of *The Fifer* intriguing, we may be leery of trying to infer from it an account of how all modernist abstraction operates. Works that contain some reference to the natural world are one thing, but what about those that are entirely abstract? How can we read the central paintings of Piet Mondrian, for instance, as figures of consciousness, when they do not refer in any way to recognizable objects of consciousness?

I agree this is a reasonable caution and acknowledge that the Sartrean interpretation cannot cover the whole field of modernist art. That field includes works that apparently do not represent objects in the world at all. I also want to note well that this interpretation does not imply that such works must be judged artistically deficient. I wholeheartedly agree with Greenberg's observation that we can determine aesthetic value only on the basis of firsthand intuition, never formulaically.[19] No methodological or ideological litmus test can guarantee the presence of beauty. Nevertheless, these concessions do not appear to me to be very damaging. For one thing, as chapter 2 testifies, I am ultimately interested in these works as vehicles not of beauty but of a kind of learning. And second, and more to the point here, I do not find that this approach actually rules out much of modernism. It has long become commonplace to associate Mondrian's paintings and other supposedly fully abstract work with spiritual or inner states

of being; indeed, it is perfectly plausible to explore how forms in such works may represent such exceptional or relatively private and idiosyncratic states. Accordingly, realizing that these forms also refer to the medium would broach the Sartrean point that they thereby mirror me not being those states.

Lingering on Greenberg's insistence that artworks have to be experienced personally permits me to clarify how I am employing Sartre here. I am not grounding my understanding of the medium on the presumed truth of the latter's systematic theory of consciousness. I realize that in the light of debates in philosophy of mind since Sartre wrote, his position would need considerable elaboration and revision to hold its own today. Indeed, I have hardly done complete justice to that position as it stands. Here as elsewhere in this book, my interest is not in fashioning an understanding of modernist art to fit authoritative, grand theories. Quite the reverse: the philosophical ideas and theories become useful only insofar as they help me articulate and understand my intuitive responses to the works. Even if Sartre's thinking above leaves something to be desired *qua* an account of consciousness, I find it nails down a key feature of my experience of modernist works, of what it is like to receive such works, and hopefully others will recognize in it their own experiences as well. (And if they do, that should say something in Sartre's favor.) The prospect of such recognitions is pretty much all I have to offer, not prescriptive proofs.

That said, I should acknowledge at least a couple of obvious ways that my Sartrean approach cuts against the grain of current hermeneutic trends. Even though I am confident that it could keep up its own end of a critical exchange with proponents of those alternative interpretive theories, this is not the place to stage arguments in detail. Let it suffice to remark that first, although I make hay out of the gap between signifier and signified, unlike mainstream structuralist and poststructuralist thinking I do not find in the gap a dissolution of subjective experience. Rather, I believe that it can represent an experience of our subjective, conscious *Unheimlichkeit* or uncanniness. In this respect, I find myself unexpectedly agreeing with Georg Lukács, that hard-line opponent of modernism, that the true significance of the turn toward medium is its turn away from a confident connection to the objective world, arousing in us sentiments of subjective isolation and angst. Of course, I disagree that this is a symptom of pathological delusion.[20] Second, I realize that what Sartre calls nihilation will seem to some like denial. Critics schooled in the unholy trinity of Marx, Nietzsche, and Freud and who have absorbed the feminist distrust of disembodiment are liable to be suspicious of a theory that insists our concrete situatedness, or facticity, is always accompanied by an absolute transcendence. Contrary to the unqualified materialism pushed by many today—remember, the author of volumes of *Situations* always affirmed a qualified materialism—I follow Sartre in wanting to register as well the part of ourselves that is out of this world. As I said, I know I have some explaining to do to these critics; in the meantime, let me continue my speculation as such.

A modernist medium resembles consciousness, then, in that in both of them objects appear that refer specifically to what they are not. The object of consciousness is not a lot of things, but it is specifically not the consciousness of it. Similarly, the object in the modernist medium is not, whatever else it may not be, what it conventionally signifies. In the latter case, the medium negates traditional signification; in the former, consciousness negates its object. Works of the latter, modernist negation, I am suggesting, can stand as representations of the former. Accordingly, the signifier that is not what is signified, in this medium, would be a signifier of the object that is not con-sciousness of it, and that draws attention to and reflects that consciousness: my consciousness, me. To call a work modernist, then, is not only to observe that it stresses its medium or that that stress expresses a political impulse of cultural negation; it is to recognize that this work captures my conscious existence in the world.

Furthermore, when I turn from such works to ordinary mirrors, this image of my existence, once acknowledged and appreciated, continues to alter my self-understanding. In effect, modernist works have the power not only to reveal our being but also to teach us not to confuse ourselves with anything recognizable. Most of the time, this lesson is hardly necessary: there is no danger I am going to mistake myself for words on a screen, even when they are autobiographical. But the sense that I am likewise not the memories those words articulate, not my skin available to others, not some inner, guarded feelings—and the more closely I examine these things, the more perspicuously I discover only what it is I am not—runs profoundly counter to common sense. For my purposes, this is the real payoff of the Sartrean analysis of consciousness and of modernism. Proponents of the notion that we each possess a definite and stable identity henceforth have the burden to show how it is possible to be such a particular thing and be conscious of being it. As I mentioned in the previous chapter, Sartre's name for the belief that one is both conscious and determinately identifiable is bad faith. Opposing that, we now have explanatory support, and the testimonial support of a whole tradition of art and literature, for Arthur Rimbaud's insight that "Je est un autre," or "I is an other."[21]

It is this insight that explains my reluctance to identify myself with most of the cultures in society today. Let me clear: I am not denying the historical, material scars that social discrimination continues to leave; like most people, I bear those scars myself. I know very well that like it or not, others will give themselves license to abuse me by insisting I possess a particular, subaltern identity. Multiculturalism has been one force that has kept this abuse in check. But we can also struggle for justice without playing the identity game ourselves. We can demand that our existential freedom to understand, our humanity, be recognized in deed as well as in word. This would be the politics of a modern-ist culture, one that is compatible with humility in the face of other political cultures and open to the possibility of forming alliances with them.

In any event, Rimbaud's epiphany radicalizes more well-known ways of linking modernism with the experience of strangeness. Bertolt Brecht famously wanted the exposed conventions of his epic theater to produce in the audience an "alienation effect." This would distance the spectator from events represented in the play so that he or she could respond critically to them and their contemporary analogues.[22] For the Russian Formalists and their descendants, successful artworks "defamiliarized" the world, as a necessary part of stimulating and reawakening senses numbed by habit.[23] In both of these perspectives, modernist works aim at strangeness as a rhetorical device to get us to attend more closely and satisfyingly to some facet of a world that is ultimately home. This differs from the Sartrean perspective I am developing here, wherein the experience of strangeness is true because the existence of even the most familiar things is foreign. Home is a name for temporary shelter in a sublime land. The modernist work reminds us we are always travelers passing through.

The strangeness of existence captured in the modernist work, the question of existence that incites existential learning: these, I am suggesting, are the same thing. Encountering in the work what I am not—confronting my own nothingness, my not-being anything—makes me aware of how deeply uncertain as well as alien existence is. That the world is, that I am, are no longer in this light facts I can assume but questions calling for my free, deliberate understanding. By providing us with occasions to rethink our understanding of our existential nature, modernist works demonstrate their pedagogical value.

Such reflections are something we have to come to terms with prior to other practical considerations. Why? Because things are practical or impractical only for beings with appropriate needs and desires. In order to feel pressed by the question of choosing a graduate area of study, and to dismiss as whimsical possibilities of exploring Antarctica, I must understand myself to be a certain kind of person in a certain situation. My self-understanding is a condition for making such choices. Now here is a conception of who I am that challenges other such conceptions, including the ones that I currently hold and that are conventionally available. It threatens to reorder my priorities and possibilities in disturbing, not easily anticipatable ways. Yet it might be true. To consider what may be truly practical for me, then, I ought to examine my experiences seriously in the light of this conception, and suspend other concerns, if possible, enough to do this. (If these other concerns seriously put at stake the very possibility of self-preservation, let alone self-examination, however, they obviously may not be amenable to suspension.) Such a matter of self-understanding should not be decided on given pragmatic grounds.

Indeed, the theory of consciousness elaborated here suggests that our practical and our existential natures may stand in dialectical relation to each other. We might speculate that consciousness initially develops in each of us in response to the need to adapt to and control our world. In this respect, we are not all that different from other animals; we simply possess more of what John Dewey calls

intelligence.[24] As we more or less deliberately extend our consciousness to cover our surroundings, however, we discover that all the things we encounter are not us—and start to wonder whether nothing is us: "for having been brought this far by nature I have been / brought out of nature / and nothing here shows me the image of myself."[25] The related projects of self-preservation and will to power, while never ceasing, thus eventually, broach a qualitatively different project of self-understanding. In the first set of projects, consciousness seeks to familiarize us with the world. In the second, it seeks to understand its own strangeness. Out of a negation of the knowledge amassed by the human animal, tied to its particular circumstances, grows the realization of being human.

Sartre shows that modernism illuminates, and is illuminated by, a certain philosophical anthropology, one that characterizes us as being fundamentally strangers to the world. Before the modernist work we have a certain experience; this experience discloses something essential about us. I call this understanding of who we are our "strangerhood." It naturalizes the estrangement that Clark finds in modernism, transforming it from a product of a certain historical predicament created by modernizing forces, into an acknowledgment of a basic condition of our existence. This does not mean that Clark or Marx or many others were wrong about capitalism aggravating alienation.[26] When misery keeps my sense of estrangement tied to others taking possession of my labor, that estrangement becomes an occasion less for reflection on my humanity than for campaigns for justice and liberation. We may be spurred to political action in the hope of eradicating such exploitation and securing the material conditions of life—but this would have no bearing on whether we could ever be ourselves unalienated, whether we could ever take full possession of our selves. To be human is to be a consciousness never coinciding with itself, roaming without a home. For such a being, its very existence and that of the world will always be questionable. Insofar as modernist works bring us to this self-understanding, therefore, they return us to the experience of existence.

Following through on the negative cast of modernism, then, does lead to a new audience for it, although not the one Clark envisaged. Modernism as the art of strangerhood has something to say not only to the bourgeoisie that gave rise to it, or to the adversaries of that class, but to all human beings. It confronts them with the disturbing fact that they exist. One might be tempted to say that modernism should therefore aspire to rise above class struggle. But a much less misleading formulation of the modernist movement, as I shall explain in chapter 5, would be that it stands for an existential, pedagogical culture predicated on the abolition of class.

Greenberg explains that modernism's stress on medium is important because it constitutes the central act of a project to purify each of the arts. He thus establishes that the modernist artwork is made for formalist analysis and evaluation, that is, for examining how elements of its medium combine and interact to produce beauty. This is a virtual axiom until this day for both modernism's

supporters and detractors. Although Clark concurs that this stress defines what is distinctive about modernism, he disputes Greenberg's interpretation of it by highlighting its irreducibly negative significance. He acknowledges modernism's formalist concerns, but interprets these as ultimately expressing political dissent. Now Sartre makes it possible for us to interpret this emphasis on negation in turn as a responsiveness to, and disclosure of, our strangerhood, all the while, once again, respecting modernism's self-consciousness about form. Encountering the medium's necessity, we may learn about the condition of our existence: this is why I claim that modernism is an existential pedagogy. But from this lesson, what others follow? The next chapter will try to draw from this understanding of our strangerhood an idea of the good that would suit this nature, an idea that is also rooted in the modernist medium.

CHAPTER FOUR

Presentmindedness

What does strangerhood look like? Jasper Johns evokes this condition in his painting *Land's End*. A hand reaches up from the blue depths; is it signaling for help? It is hard to be sure, because none of the signs in this work are stable. The word "red" is colored red, but it is also colored blue and is used as a set of shapes that can be mirrored in reverse. Below that is "yellow," colored blue, with a "y" stencil depicted illusionistically peeling in profile; and below that, "blue" is painted red and orange, with variations on its letters falling away. At the top right corner, a ruler has scraped these primary colors together, blurring them and covering the surface up even as it pictures its movement; a corresponding, indexical principle seems to govern the brushwork in general. Underneath this ruler-device, finally, an arrow gratuitously points down.

Bewilderment before this medium of signs of signs, panic at their disintegration and layered obscurity, helplessness in the face of the task of grasping all this: these are the sentiments the work conjures up for me. The previous chapter argued that modernist art is not ultimately about medium, but establishes, via the stress on medium, the priority of the experience of existence, of our strangerhood, to given practical considerations; this is one measure of its pedagogical capacity to lead us back to that experience. However, even if the experience cannot be denied on the grounds that it diverts us from ongoing projects, if it were as disorienting and paralyzing as Johns's pictures, would it not dead-end in a kind of skepticism that is impractical in essence? Would it not leave us unable to get up out of bed? Or is it capable of leading also to what Charles Taylor calls a "moral orientation," a sense that we are attracted and committed to a particular vision of the good, a sense of how we should live?[1] Recasting this last question with regards to modernism, can the mediumist art, or pedagogy, that provokes us to acknowledge our condition of being strangers also bring us to an understanding of what we love in this condition?

To explain how it can, I shall begin by examining a critical response to Clark's claim that the medium in modernism is a site of negation. Michael Fried contends that it is a site of conviction, what he calls "presentness." After using

work of Stanley Cavell to elaborate and extend Fried's reasoning, I shall argue that modernist works actually contain and combine both these dimensions of negation and affirmation, albeit in a way that revises Clark's and Fried's thinking. Such works confront us with our strangerhood, and they orient us, as existential strangers, to the good that is the Present. They acknowledge a particular philosophical anthropology, and they find in that acknowledgment opportunity to celebrate a matching ethics. This process of acknowledgment and celebration modeled in these works is a kind of existential learning.

PRESENTNESS AGAINST STRANGERHOOD

Fried replies directly to "Clement Greenberg's Theory of Art" with "How Modernism Works: A Response to T. J. Clark." In some respects, his is a Greenbergian rejoinder, but with a twist. As Greenberg might, Fried attacks Clark's emphasis on negation: "In 'mainstream' modernism . . . there is at most a negative 'moment.'"[2] The modernist's ultimate aim, however, is to create works that can stand comparison with the best works in the same artistic tradition. Here is how Fried puts the fundamental contrast between his and Clark's positions.

> To the extent that we acknowledge the need for a putative work of modernism to sustain comparison with previous work whose quality or level, for the moment anyway, is not in doubt, we repudiate the notion that what at bottom is at stake in modernism is a project of negation. For it is plainly not the case that the art of the old masters—the ultimate term of comparison—can usefully be seen as negative in essence: and implicit in my account is the claim that the deepest impulse or master convention of what I earlier called "mainstream" modernism has never been to overthrow or supercede or otherwise break with the pre-modernist past but rather to attempt to equal its highest achievements, under new and difficult conditions that from the first were recognized by a few writers and artists as stacking the deck against the likelihood of success.[3]

The old masters stand for quality. Although it may seem that modernist works are doing violence to these standards—transgressing, parodying, or otherwise subverting them—these works are better comprehended, in the sense of having more of their features appreciated for their significance, to be actually striving to match or surpass the standards. Central to the modernist work are thus two claims: one to aesthetic quality, and another, since that quality can only be determined comparatively, to belonging to a tradition. Together, these entail affirming precedent.

But if this were the case, then what accounts for the undeniable fact that such works hardly look like their predecessors? Why is it not accurate to describe this look as the expression of an ambition to distance these works from any such comparisons? Fried's theory of modernism appears to be disconfirmed by

the works themselves, for it should entail, should it not, that the similarities between them and their predecessors would clearly outshine their differences.

The answer to this objection must lie in the "new and difficult conditions" under which modernist artists are operating. These conditions, as we saw, amount to a crisis in the traditional arts, one such that the normal criteria for comparing works in each tradition have become questionable. At one time, for example, the grounds for recognizing works by Giotto, Da Vinci, Caravaggio, and Watteau as all paintings, and for determining their respective merits, were fairly straightforward. But from Manet and Cézanne on, not only did it become harder to see how Barnett Newman, say, measured up to Giotto, but it became reasonable to wonder in what sense Newman is a serious painter at all. This crisis resembles that of revolutionary science, where, according to Thomas Kuhn's classic account, theoretical work is required to wholly revise a traditional paradigm so that it might be capable once more of taking in new data and reconciling it with old facts.[4]

The crisis may also seem to call for work to address its contextual causes: as Clark points out, this would be the logic that necessitates the adoption, on the part of all concerned, of an explicitly political stance. But Fried objects to such an understanding of modernism as "crude and demeaning."[5] It is unfortunate that he does not explain at length his strong reaction—which leaves him looking suspiciously reactionary—but a Greenbergian reason is readily available. If the crisis is indeed one in which the arts are exposed to ideological as well as commercial exploitation, as we witnessed Greenberg argue earlier, then it would make sense that the solution cannot entail politicizing them in any ordinary way. For turning art into agitprop, even for the "right" side, would be to abandon the very qualities that the crisis put at risk. Clark's call for art *engagé* not only would make modernism beside the point, it would give up on the distinctively aesthetic values that modernism is striving to conserve. This is why Fried rejects his diagnosis and prescription. (Although I think this would be a reasonable rejoinder on Fried's part, it is not conclusive. It begs the question of Clark's claim that the question of aesthetic value in modernism is ultimately one about the acceptability of the bourgeois, philistine social order.)

To meet this crisis, on the contrary, artworks need to reestablish conventional criteria that would enable us to compare them meaningfully with their precursors. Instead of taking for granted that comparison is possible, that kitschy simulations of classic genres pose no problems, or presuming that they are incomparably compelling, that they can live on originality alone, modernist artists have to accept responsibility for the additional task of not only presenting plausible candidates for comparison but securing the basis on which that can take place. This basis can only be found in the medium of each art. For Fried, modernist art is characterized by a search in artistic mediums for criteria that can support conviction in a work's identity as an instance of an artistic tradition

and in the work's relative aesthetic merits. Arriving at such conviction is the entire point of aesthetic judgment and debate, not to mention creation.

Against Clark, then, Fried characterizes modernism as an aesthetic rather than political project of renewal rather than negation. So far, so Greenbergian. The twist comes when he suggests that Clark's mistake might have been to derive his emphasis on negation from a reductionist tendency in Greenberg's own thinking. Clark, it turns out, is the one who follows the master too closely. Greenberg defines modernism as a project of self-critical purification, eliminating from each art all contamination. In an art's pure state, it is the strictly indispensable, analytically essential elements of the medium that enable meaningful comparisons to be made between works of that art. Now Fried suggests that although Clark in the end has little interest in such an essentialist quest, he was perhaps too enthralled by Greenberg's characterization of modernist art-making as elimination. He evidently carried that characterization over into his conception of negation.

Fried agrees with Greenberg that modernism is a matter of self-criticism, medium criticism; however, he envisions that self-criticism differently. Rather than cleansing the inessentials from the Platonic forms of each art, Fried accepts that all the organizing principles of an art are historically contingent, having heterogeneous origins. They are mutable conventions. The appropriate quest is that to establish which conventions permit convincing comparison today; tomorrow, unpredictably, it may be a matter of different conventions. Such an inquiry must therefore proceed not deductively but experimentally, with the guidance not of *a priori* definitions but *a posteriori* precedent. Moreover, it does not require any acts of elimination or negation, simply ones of changed emphasis as formerly unconscious procedures and premises are charged, upon reflection, with new significance. The resulting work affirms the capacity of these conventions to organize forms of beauty that measure up to the best works of the past, although the fresh prominence given to these conventions accounts for why the work appears to depart so strikingly from tradition.[6] Accordingly, in the sixties, Frank Stella wanted to paint as well as Velázquez; in order to do so, he placed new stress on painting's shape, making artfully coming to terms with that shape part of the medium's challenge to any painter.[7]

My insistence that the modernist painter seeks to discover not the irreducible essence of all painting but rather those conventions which, at a particular moment in the history of the art, are capable of establishing his work's nontrivial identity as painting leaves wide open (in principle though not in actuality) the question of what, should he prove successful, those conventions will turn out to be. The most that follows from my account . . . is that those conventions will bear a perspicuous relation to conventions operative in the most significant work of the recent past, though here it is necessary to add (the relation of perspicuousness consists precisely in this) that significant new work will inevitably transform our understanding of those prior conventions and moreover will invest the prior works

themselves with a generative importance (and isn't that to say with a measure of value or quality?) that until that moment they may not have had.[8]

What seals the sense of "discovery" here—of something being "established," of a "perspicuous relation" being recognized—is the crystallization of conviction in the work. In "Art and Objecthood," an earlier essay that represented the culmination of his understanding of modernism and from which his response to Clark proceeds, Fried characterizes this crystallizing moment as an experience of "presentness."[9] Shortly, I shall concentrate my examination of his theory of modernism on what he means by this term. My reason for this slight shift of focus is that his critique of Clark, however engaging and insightful, particularly in its capacity to provoke in turn a spirited reply by Clark—the latter amplifies his picture of modernism's negativity and questions the implicit religiosity of Fried's view—is significant for my purposes ultimately because it bears on the sense of strangerhood I find in modernism: it challenges my argument of the previous chapter. I shall briefly return to the debate between Fried and Clark in the next chapter, where I will address the question of whether there are any purely aesthetic values as part of an investigation of modernism's politics. In the meantime, rather than dwelling on an assessment of Fried's criticism of Clark, then, I propose to continue to draw out the implications of its account of modernism for my own. I should perhaps note once more that my aim here is not the same as Fried's, Clark's, and Greenberg's: that of working out an explanation of the nature and course of modernism. It is rather to explain how many (though doubtless not all) works that have largely through their accomplishments come to be called modernist may be useful in fostering existential learning. To stay on this track, I have to skip over otherwise interesting points of historical interpretation and aesthetic judgment at issue between the three critics.

Conviction in a work's aesthetic identity and quality: this, then, springs from an experience of presentness. In its grip, we are fully present to the work, and "get" all its features as a whole. Presentness constitutes the ultimate payoff of any beautiful artwork, modernist or traditional, yet, as one might imagine, it is difficult to describe, difficult to explain how one recognizes it when one experiences it. Here is Fried's attempt in "Art and Objecthood," referring to the sculptural work of Anthony Caro.

> It is as though one's experience of [modernist painting and sculpture] *has no duration*—not because one in fact experiences [such works] in no time at all, but because *at every moment the work itself is wholly manifest*. (This is true of sculpture despite the obvious fact that, being three-dimensional, it can be seen from an infinite number of points of view. One's experience of a Caro is not incomplete, and one's conviction as to its quality is not suspended, simply because one has seen it only from where one is standing. Moreover, in the grip of his best work one's view of the sculpture is, so to speak, eclipsed by the sculpture itself—which is plainly meaningless to speak of as only partly present.) It is this continuous

and entire *presentness*, amounting, as it were, to the perpetual creation of itself, that one experiences as a kind of *instantaneousness*, as though if only one were infinitely more acute, a single infinitely brief instant would be long enough to see everything, to experience the work in all its depth and fullness, to be forever convinced by it.[10]

Without worrying too much about the figurative nature of this description, let us identify the main elements in its chain of associations. Presentness is an experience that is instantaneous. In that instant, the work is completely manifest. Being so manifest, we absorb the work's full meaning and beauty and grasp the rightness of its elements and composition. We are thereby convinced by it: it is in the same league as the best of that art. And since no further meaning or beauty remains to be experienced, the work simply recreates itself whenever we encounter it afterward.

This experience is patently an ideal state of being for us. "We are all lit-eralists most or all of our lives," the essay famously concludes; "presentness is grace."[11] Deferring for a second the question of what is meant by "literalist," it is clear that presentness amounts to an exceptional and redemptive event, a perfect condition we only rarely approximate. Its value is to be distinguished from its more mundane, incomplete, inconclusive counterpart, the experience of presence. The latter, Fried argues, is the characteristic effect of certain pseu-domodernist, pseudoartistic, minimalist works.

"Minimalism" refers here to a movement in sixties American visual art that appeared to minimize the amount of incident in its works. The term has since been extended to cover analogous works in other arts, particularly music. James Meyer provides an illuminating history of the movement, and Gregory Battock, a collection of contemporary artist and critical texts.[12] Fried's preferred term for minimalist works is "literalist;" as we saw above, he sometimes uses the term to refer to the sensibility behind such works. These works contrive to stifle their signifying and representational powers to a degree that surpasses most abstract sculpture and painting; the mediums are given next to no forms with which to demonstrate how they operate. The works are literally what they are, noth-ing more. But this way of describing them focuses on what they are not; Fried is more interested in their positive qualities. He observes that they project objecthood: the sense that in being literally what they are, they are like any other object in the world. When we experience these works, we experience the quality that is common to all objects, regardless of their differences. This is, recalling Wittgenstein, not how things are in the world, but that they are, their presence. This stress on presence invites us furthermore to characterize the literalist sensibility behind the work as being interested in projections of a kind of cool. The cool person does not do, but effortlessly, stylishly, is.

Presence is obviously closely related to presentness. I am present to a work, but someone else is absent to it; the work has presence for me, but not for

another. Being both concerned with the sheer existence of a work for someone, the fork in the road Fried registers regards how one experiences this existence. How does presentness differ from the experience of something having presence?

Fried's remarks on the latter are scattered throughout the text, obliging us to reconstruct his answer. Presence is an experience of "an object in a *situation*—one that . . . *includes the beholder*."[13] The object "*distances* the beholder," making him (Fried stays with the masculine pronoun) self-conscious about being a beholder confronted by this particular object in this particular situation.[14] This self-consciousness deepens into something like an imperative that I wake up to where I am: "Something is said to have presence when it demands that the beholder take it into account, that he take it seriously—and when fulfillment of that demand consists simply in being aware of the work and, so to speak, in acting accordingly. . . . The beholder knows himself to stand in an indeterminate, open-ended—and unexacting—relation as *subject* to the impassive object on the wall or floor."[15] As the sense of impassiveness sinks in, however, what I awake to is that there is something hidden about the object. Twice, Fried quotes Tony Smith's statement that, "I'm interested in the inscrutability and mysteriousness of the thing."[16] Another literalist, Donald Judd, suggests that this inscrutability resides in the thing's materiality. Indeed, its being made of these specific materials is equivalent to its being literally itself.

> The materials do not represent, signify, or allude to anything; they are what they are and nothing more. And what they are is not, strictly speaking, something that is grasped or intuited or recognized or even seen once and for all. Rather, the "obdurate identity" of a specific material . . . is simply stated or given or established at the very outset, if not before the outset; accordingly, the experience . . . is one of endlessness, or inexhaustibility, of being able to go on and on letting, for example, the material itself confront one in all its literalness, its "objectivity," its absence of anything beyond itself.[17]

This brings us to a last feature of the experience of presence: its palpable temporality: "The experience in question *persists in time*, and the presentment of endlessness that, I have been claiming, is central to literalist art and theory is essentially a presentment of endless or indefinite *duration*."[18] Conscious of myself in this particular situation, confronting this enigmatic object made of these specific materials, I become aware as well of the time dragging through all this, "simultaneously approaching and receding, as if apprehended in an infinite perspective."[19]

The contrast with presentness should now be apparent. Presence is not instantaneous, but extends over time. It is an experience not of an artwork, but of an object, and of the individual subject, in a situation. In it, I do not lose myself in the artwork, but I become conscious of myself standing apart from the object. The latter distances me because it is not completely manifest; it hides

something. It blocks insight into its meaning with the prominent opacity of its materials, their distinct but unsignifying quality. As a result, I am challenged to pay attention to this specific object in this specific time and place, much as if I were hailed, but nothing else is asked of me. In particular, the object does not demand that I make any effort to judge it, that I open myself to being convinced that it is beautiful. Instead of experiencing how the artwork instantaneously recreates itself every time I renew conviction in it, I experience how the object simply lasts.

At the core of the experience of presence is the link between my self-consciousness and the hermetic literalness of the object. I become aware of myself in relation to something that is simply there, without any explanatory or associative meaning. Thus presence is another name for what I have been calling strangerhood, the experience of our condition as beings. Yet if Fried is right, if the proper accompaniment of modernist artwork is presentness, not presence, then I must be wrong in claiming that strangerhood is a moral of modernism. Fried's sharp distinction between these two modes of being undermines my understanding of the modernist medium.

But why exactly is presence anathema to modernism? Why could not there be modernist works that project presence rather than presentness, in the same way that there are ones that convey wittiness rather than weightiness? One reason has already been touched on. Presence involves a stress on suchness, to refer, like John Cage, to a key Buddhist idea, and the latter runs counter to the call to judge the artwork's aesthetic quality in careful comparison to others'. No shared standard exists among literalist works to give meaning to their differences; there is only their common, vacuous resemblance to any other existing thing. For this reason, Fried expressly denies that the experience of presence is at all aesthetically significant; there is no place in it for considered taste. Surface looks can be deceiving: just as modernist artworks are allied with traditional artworks despite their dissimilarities, so literalist objects, like some works of dada or agitprop, are actually opposed to modernism despite their resemblances. They represent another attack on the aesthetic qualities that modernism is struggling to protect.

The other reason for Fried's denigration of presence, and by extension of the experience of strangerhood, is that he finds the experience unscrupulously theatrical: "The presence of literalist art . . . is basically a theatrical effect or quality—a kind of *stage* presence. It is a function not just of the obtrusiveness and, often, even aggressiveness of literalist work, but of the special complicity that that work extorts from the beholder."[20] Against my claim that the experience can root a sense of authentic self-understanding, that it discloses I am most myself when I acknowledge I am a stranger in existence, Fried contends that there is something forced, fake, and corrupting about it. For him, it is the real form of bad faith, and the connection to cool, to the implications of that style, is

all the more reprehensible. "There is a war going on between theater and modernist painting, between the theatrical and the pictorial—a war that, despite the literalist's explicit rejection of modernist painting and sculpture, is not basically a matter of program and ideology but of experience, conviction, sensibility."[21] That this cool sensibility can incite in Fried such militant sentiments indicates that he sees something more destructive in it than playful affectation.

In later, more historical work, he explores the emergence of this scruple against theatricality in the visual arts, tracing it back to the evolution of French painting in the mid-eighteenth century.[22] He refers to this period as the "age of Diderot," resting his interpretation on the latter's prominence as the leading art critic of his day and a prophet of ours. Fried plausibly details how many of the terms and criteria of Denis Diderot's criticism can be organized around his central antipathy to theater. Here Fried quotes and elucidates some characteristic passages.

> "If you lose your feeling for the difference between the man who presents himself in society and the man engaged in an action, between the man who is alone and the man who is looked at, throw your brushes into the fire. You will academicize all your figures, you will make them stiff and unnatural." In that event the painting would no longer be . . . "a street, a public square, a temple"; it would become . . . "a theater," that is, an artificial construction in which persuasiveness was sacrificed and dramatic illusion vitiated in the attempt to impress the beholder and solicit his applause.[23]

For Diderot, theatricality is pandering to the audience at the cost of aesthetic truth. This critique is in line with Jean-Jacques Rousseau's contemporary, but more comprehensive and radical attack on *amour-propre* as the root of our deviation from nature; this in turn carries on the Augustinian struggle against the original sin of vanity.[24] Fried's condemnation of theatricality, then, is hardly unprecedented. What is more difficult to see is how it bears on literalist work.

The pertinence is perhaps best explained by Stanley Cavell, with whom Fried has shared interests and exchanged ideas for much of their careers. "Art and Objecthood" contains a footnote referring us, on the subject of theater, to Cavell's "The Avoidance of Love: A Reading of *King Lear*;" the following passage from this essay in turn contains a footnote, which I will not reproduce, that discusses "Art and Objecthood."[25] In this passage, Cavell offers us a quasi definition of the theatrical that focuses less on how it corrupts actors and more on its effects on, the "special complicity" it extorts from, spectators. He explains what it would mean to say that Shakespeare's play is trying to overcome, by acknowledging its theatricality, the absence of its audience to its actors. (His argument that *King Lear*'s subject matter extends to this formal concern amounts to a reading of the play as modernist.)

> How do we put ourselves in another's presence? . . . By revealing ourselves, by allowing ourselves to be seen. When we do not, when we keep ourselves in the dark, the consequence is that we convert the other into a character and make the world a stage for him. There is fictional existence with a vengeance, and there is the theatricality which theater such as *King Lear* must overcome, is meant to overcome, shows the tragedy in failing to overcome. The conditions of theater literalize the conditions we exact for existence outside—hiddenness, silence, isolation—hence make that existence plain. Theater does not expect us simply to stop theatricalizing; it knows that we can theatricalize its conditions as we can theatricalize any others. But in giving us a place within which our hiddenness and silence and separation are accounted for, it gives us a chance to stop.[26]

In somewhat elliptical fashion, Cavell is opposing the condition where we "put ourselves in another's presence," where we acknowledge the other so that we may be acknowledged—a paradigm instance being a simple greeting—to the condition where we secret ourselves from the other so that we may treat him or her as a spectacle. The latter constitutes the theatrical. Manifestly, it constitutes the central convention of the art form in which people watch others who act as if the former did not exist. Cavell is interested in how this convention allegorically addresses forms of theatrical conduct outside the playhouse. This interest is precisely in line with my more general one in how exposure of an artwork's medium allegorically discloses our strangerhood.[27]

To call literalist art theatrical, then, is to remark that the artist invites us to treat the object as "a character and make the world a stage for him." What makes such art morally suspect as well as antiaesthetic is that it encourages our proclivities to withhold ourselves from acknowledging, and being acknowledged by, others, to avoid mutual exposure. To be cool is to disengage oneself. In the ideal instant of presentness, the work acknowledges me by presenting itself fully to me for evaluation; conversely, I acknowledge it, as it were, by revealing myself in my judgment, which can in turn be subject to agreement or disagreement, praise or scorn. Contrariwise, the literalist object projects only an uncommunicative, indifferent existence that places me in a state of solitude at a safe, beholding distance. Impressed by its cool presence, wondering at my sublime strangerhood, I am apt to forget, or deny, that unlike the object, I am responsive to others and responsible to their claims on me.

Fried's account of modernism, which I have derived from his reply to Clark and from "Art and Objecthood," raises two serious problems for my previous chapter's argument. First, he explains how a sense of strangerhood is characteristically projected by literalist works that are opposed to modernism. Indeed, such works are not authentically artworks at all, because they reject aesthetic evaluation and affiliation to an artistic tradition. He thus furnishes a reason to dispute my claim that the modernist medium reveals our strangerhood, arguing in effect that if a work were truly to do this, it could not be modernist or ruled by a genuinely artistic medium.

The second problem is even more troubling for existential learning in general. Let us say that we are willing to relegate concern for our strangerhood to comparatively nonartistic modes of discourse, such as philosophy. Fried, in the company of Cavell, would still want to denounce that way of understanding ourselves as being morally perilous. They would criticize the experience of strangerhood, of existence, for being a kind of indulgent escape from our responsiveness and responsibilities to others. If this were the case, then it would hardly make sense that the experience could lead to any kind of tenable good. What, then, could be the value of existential learning?

THE ETHICAL PRESENT

"Art and Objecthood" is notorious for its stridently Manichean tone. As a consequence, the ensuing critical triumph of minimalist art came largely at the cost of a total repudiation of Fried's understanding of modernism. It seemed to many that he must be either wholly right or wholly wrong. My response is going to take a different tack. I see that his theory explains how many modernist works enter into conversation with their contemporaries and precursors. He develops Greenberg's insight into medium, while astutely revising the latter's essentialism. Although I shall contest some of the implications Fried draws from them, his phenomenological descriptions of the experiences of presentness and presence are brilliantly illuminating. Finally, while I have left his debate with Clark hanging, I find his defense of the affirmative point of modernism impossible to dismiss. Indeed, I want to explain how joining modernism to the project of existential learning strengthens its celebratory power. To do this, however, I need to explain how these projects can be reconciled, and to accomplish that, I need to show that modernism and minimalist, literalist work are not in fact enemies.

The territory in dispute between them, so to speak, is the experience of strangerhood. Fried aligns this experience wholly with literalist work. In the process of doing this, however, he uncovers in the experience the seeds of something that is in its own way affirmative. I shall try to spell this out more fully and explain how this affirmation can amount to an ethics for existential strangers. By establishing a positive meaning for strangerhood, I hope that the aesthetic validity of the art that celebrates it—indeed, the validity in quintessentially modernist terms—will become evident.

Literalist work is not modernist, according to Fried, because it is interested in strangerhood, not presentness. Bracketing for the moment the truth value of this claim, what remains intriguing is the notion that someone might have this interest at all. What could conceivably be good about dwelling on this condition? One answer, of course, is that it is simply better to know the worst, that we are theatrical beings, rather than live under an illusion. Another is that dwelling on this *is* a flight into illusion. But I wonder if there is not a more

compelling reason to register the experience of strangerhood in art, one that Fried intimates in his perceptive description of works of presence.

Recall the distinguishing feature of these works that above all draws our attention: their literalism. How do the works focus our attention on the fact that they are literally what they are? Not only by not giving us much else to notice but more positively by exhibiting interest in the materials of which the work is made. (Since I noted above that a body of so-called minimalist art eventually won recognition over Fried's objections, this is perhaps the place to note as well that not all such art stresses its materiality or is essentially literalist in his sense. Fried is only a partially reliable guide to the nature of much of this art; his analysis fits, more or less, the work of Judd or Carl Andre, but not as much that of Sol LeWitt or Dan Flavin. Still, as long as his interpretation is applicable to some body of work, we can validly consider its and these works' philosophical significance and educational uses.) What brings me to an awareness of the work's literal identity, and to a self-consciousness about my strangerhood, is my confrontation by the work's materials—"confrontation" because they have been assertively displayed. Usually, an artwork employs its materials to embody and support its forms. This work uses forms that make their materials, and their specific properties, extraordinarily conspicuous. Now we are trying to imagine how the art that brings me to this experience of strangerhood could be an affirmative one. We might accordingly speculate about whether, following through on the experience and in a sense compensating for it, there might be something rewarding about this focus on the work's materials.

What stands out about them, I find, is the fact they preexist the work. If we wanted simply to learn about the materials or experience their properties, we could do that outside of an artwork. The property that comes to the fore when we confront them in an artwork, surprised that they do not give way to the usual demonstrations of virtuosity, though, is their ontological priority. The materials exist before any work is done with or on them; they do not appear to be a product of the artist or ruled by his or her desires. I hasten to emphasize that I am offering a phenomenological description here: objectively speaking, it may well be the case that the materials took quite a bit of effort to fabricate. Judd, for one, was fond of alloys. But in my experience, this work tends to retreat into invisibility, being overshadowed by the starker contrast between the materials and the formal work they normally support. Think of the passersby glimpsed in a film: we know that they are acting too, nevertheless we tend to lump them together with the documented setting and see both as simply props for the real, foregrounded acting, not to mention the staging, camerawork, and editing. Similarly, it is one thing to know that materials precede the work definitionally, another to actually experience this priority. We experience it when the artist puts his or her actions, and the resulting forms, in the service of revealing what preexists his or her work, when the artist reverses so strikingly the usual instrumental subjection of the materials. In this, Cage is an exemplary pioneer.

Of course, this raises the question of what is so interesting about the phenomenological priority of materials to work and its products. The answer starts to emerge when we see how this priority echoes the more primordial one of matter to causation. At bottom, there must be some kind of matter that is not the product of causal work, but its precondition. Even the Big Bang had to have had something to work with. Attention to the work's materials, instead of simply confirming literalness, I am suggesting, evokes the absolute priority of matter. The sheer existence, presence, of matter is something mysteriously, miraculously given.

Again, so what? Why should the prior givenness of matter attract and hold our attention? Is this not something we can take for granted so that we may move on to more significant issues? We can—but what attending to the priority of matter broaches is the possibility of responding to it in a different way. Instead of taking matter for granted as something that is given—given to our elaboration, as the constructivist temper of our time would have it—I could consider it as something that is offered, and thus calls to be accepted. Instead of equating the priority of matter with its givenness, the latter implying automatic possession, I could stop and reflect on another possible meaning of this priority: that matter is acceptable. Similar to the way I accept jobs and gifts, I may accept offered material, matter, by appreciating what it brings to me, including certain responsibilities. My acceptance of matter in the largest sense, of the miraculous offer of existence, would involve an affirmation of that offer, and some understanding of what there is in it to love. Without that affirmation, it makes sense to refuse the offered matter by denying its value.

This interpretation of what is distinctive about literalist work revises Fried's account. Following him, I ground the work's literalness on its stress on its materials. Furthermore, I do not gainsay that this stress amounts to a projection of objecthood in the sense that it emphasizes that the work's materiality likens it to all other physical objects. Where I veer away from Fried is that he takes this to be a deflationary point, an abandonment of the qualities that would distinguish the genuine artwork. Although I allow that the work's aesthetic credentials need to be secured, and will try to do that shortly, I find objecthood to be rather a red herring. The more direct and meaningful chain here is that from materiality to matter to the priority of the offering of existence. The materiality that characterizes the literalist work can be more significantly interpreted not as something it merely has in common with other objects, namely, physically extended substance, but as that quality that effectively conveys what it has to celebrate; literalism, I want to stress, has a strongly positive meaning. To be attracted to the work's materiality, to its exemplification of the fundamental priority of matter, is the first step toward affirming existence. It is characteristic of the literalist's sensibility to focus on the very things that most people take for granted as trivially given: the materials of the artwork, the matter of causation, existence itself. He or she deliberately accepts these as grace, as good.

I propose to call this good to which literalist work directs us, the Present. The Present is what exists here and now; it is closer to us than anything in the past or future, anything we have to mourn or can only hope for or fear. It is also what exists as an event of offering. Think of birth, one of its nearest analogues. Birth need not be viewed as something that happens at one historical moment and then passes away; rather, it can be considered that quality that links every moment of our lives to the offering of being. Until the moment of death, we are thus always being born; life is perpetually being offered to us for our acceptance. Offered by whom and why, we may wonder. But speculative answers to this question, such as appeals to some divine purpose, I worry, are apt to transform the offering into something that has a reason for being, something necessary that we can therefore assume. The experience I am referring to is precisely one where we do not take existence, matter, for granted, but rather marvel at the contingent, ongoing event of offering that is matter. Theologically speaking, the Present is based on the priority of grace to God.

Yet our response to it does not stop with marveling. In calling the offering, the Present, the good of literalist work, I am leaning my account of what there is to love in that work toward an ethics. My reason is that accepting the Present entails accepting certain practical commitments. I remarked earlier that acceptance implies some appreciation of what is being accepted—some appreciation, in this case, of existence. I am apt to feel awe at its miraculous, inexplicably spontaneous genesis. And inasmuch as I find existence good, I will experience its genesis as generosity. Appreciating this, then, commits me to two familiar virtues. First, that of gratitude: the generous Present itself, regardless of its causal agent, calls for thankful recognition. Second, it challenges me to emulate its generosity by conducting myself in the same spirit with others. I should look for opportunities to act as the Present for someone else. Evidently, how I should respond to the Present in particular situations, how I should express my gratitude and my generosity in different circumstances, will be a matter of Aristotelian practical wisdom. Moreover, there can be no question of requiring gratitude or generosity: the ethics I am articulating here is one not of obligatory action but of the good life, not of duty but love.[28] The principal point is that if I fall in love truly with the Present in literalist work, then I would be committed to an ethical way of life ruled by these twin virtues. Give whenever you can; always be thankful; never presume.

Fried identifies in literalist work an interest in presence, in strangerhood. In probing this interest, I have found that it leads to recognition of the Present. What this revision of Fried's argument allows us to see, then, is why one might want to dwell on the experience of strangerhood. Although many, like Johns, have testified to how skeptically disorienting and paralyzing this experience can be, literalist work shows that the paint's presence in the labyrinth of signs of *Land's End* may serve as Ariadne's thread. Acknowledging our condition as existential strangers amounts to a first step toward accepting and celebrating

the Present of existence. Although this acknowledgment is liable to estrange us from our given ethical identities, it offers us access to one rooted not in "how things are in the world, but that it exists." It is hard to imagine deeper grounds.

Before we unpack further the implications of this ethics, though, we should return to the two problems Fried found with literalist work in order to see if they still hold after we have revised his account of that work. Does the idea that the work aims to disclose the Present enable us to compare it critically to other artworks in a tradition? Does that idea allay concerns about theatricality?

On the first score, that it surely does becomes clear once we shift the work's significance from the projection of objecthood to that of materiality. The literalist work draws attention to its material elements and their comparative qualities. It is there that we are supposed to look for aesthetic value. The reason this place can hold such value is that these elements and their qualities are a necessary dimension of the work's medium. By stressing them, the work is functioning in typical modernist fashion; its literalism is a species of modernism. We would expect—and I shall test this expectation against concrete examples in the sixth chapter—that we may make sensical judgments about how beautifully a work glorifies its materials, and by extension its material existence, in comparison to another. Nothing in principle blocks such evaluation.

Indeed, the historical success of literalist work in an art world under the sway of Greenbergian thinking need not be ascribed to its audience's abrupt incompetence or fickleness. It suggests that Fried and other modernist critics were too narrow in their understanding of the artistic medium. Fried concentrated on its anthropocentrically conventional features and neglected the dimension of the medium that must preexist human work. This success also need not be read in Clarkian terms as the rotting away of art into "mere unworked material." Far from being "mere," I believe we can find in this raw state the unencompassable surplus of being. I would suggest that literalism or minimalism was experienced by many as a breakthrough to the affirmative point of stressing medium. This is why, for all its cool, it was capable of exciting exuberance.

It should be emphasized that to see the medium is composed of matter existing prior to any work does not mean that work is not indispensable to make this visible. This is another reason why the notion of objecthood is misleading: ordinary objects precisely do not draw attention to their materiality, let alone their existence. As Heidegger explains, we tend to treat most things as equipment or resources ("standing reserve") to be used to accomplish our purposes.[29] We rely on the thing to support a project of ours and attend mainly to its relevant features, especially when they betray a degree of unreliability. It takes deliberate work, artistry, to shift attention away from such features and concerns, and toward the thing's prior, material being. Such art grows in importance to the extent that everything, including cultural works, is valued more and more exclusively in instrumental terms.[30] Just as modernism emerges out of a concern for the exploitation of art, so literalism addresses an intensification of this concern by deepening

the former's resistance. In an age when artworks are continually subjected to electronic reproduction and decontextualization, the insistence on materiality amounts to a defense of what cannot be so manipulated without being destroyed.

Literalist work is modernist in its stress on the medium's materiality. It is modernist as well in that it addresses the experience of strangerhood. In chapter 3, I explained how that experience may be stimulated by the gap between the object of consciousness represented in the medium and the consciousness the object is not. In this chapter, we have been exploring how the experience may be triggered by the above stress. I see no reason why we cannot put these accounts together and propose that modernist work in general, by virtue of both the consciousness and materiality of its medium, evokes our strangerhood in the face of existence. This would reconcile Clark's emphasis on negation, revised as nihilation, with Fried's interest in affirmation, now extended to literalness. Experiencing existence can be intensely disorienting as we feel there is no home to move from or to. However, noticing that existence is material offers us a way to recognize the prior Present. Our condition as existential strangers makes it possible for us to love the miracle of existence, and to commit ourselves to a way of life guided by that love. The work may thus enable us to realize that acknowledging our strangerhood broaches a moral orientation to a particular vision of the good. From the modernism of which literalism is a dimension comes a thoroughly classical ethics.

We can now see that little remains of Fried's second problem of theatricality. We may concur that if one were to remain sunken in one's strangerhood and found no way to rise from awareness of this condition to appreciation of anything else, then that would resemble the state of narcissistic unresponsiveness that Fried and Cavell decry. However, the ethics we have been articulating is concerned precisely with overcoming that fall into theatricality. To be sure, it strives to do this by initially courting the fall: it does not moralistically reject experiences of strangerhood but acknowledges them as revelations of our true condition. Once more, however, it finds in that acknowledgment, in this realization of one's solitude, the opening to its redemption. The alternative would be to live running away from who one is; as we shall see, this has become second nature to many of us. Furthermore, the redemptive Present is that in which all existing things, without exception, participate. My love of the Present is a form of communion, responding to the radical root of all community.

In this respect, a better metaphor for understanding why and how the modernist work isolates us is Søren Kierkegaard's concept of "indirect communication."[31] Unlike that of theatricality, it emphasizes that isolation, indirection, can serve the cause of a fuller, exceptionally meaningful communication. Kierkegaard argued for, and enacted, a form of writing that would repulse the reader's, my, expectations of and need for reassurance, throwing me, because of its unreliability or paradoxicality, back upon myself. At the same time, the writing would heighten my interest in the wisdom it promises. The result is not simply puzzlement and

frustration, but hopefully the realization that I must, and can, trust in what little I apprehend of this passionately longed-for wisdom, that indeed relying on my own gift for faith is the very pith of the wisdom. I as reader learn how to depend not on external authorities but my own inwardness—but this lesson is provoked by a work of indirect communication from others like Kierkegaard sharing this faith. In parallel fashion, modernist works draw my, the reader's (viewer's, listener's), attention to their medium and my own estrangement; I am thereby isolated. But corresponding to the possibility of discovering that solitude is requisite for faith is that of realizing it is necessary for a moral orientation to the Present; this orientation then completes an act of communication that puts me in touch unconditionally with others. Even though I can never renounce communicating in conventional ways or cease to suffer confusion and its consequences, the experience of the Present, of existence as a present, cheers me, as Ralph Waldo Emerson would put it, with the sense that there is a community to which I have always belonged and from which no misunderstanding can separate me, one governed by gratitude and generosity.

Modernism's essential indirection demands that we revise as well, finally, Fried's prizing of presentness. Presentness grounds belief in an artwork's quality on an experience of its instantaneous, complete, absorbing manifestation: taste is conviction or not at all. In comparison, the experience of the Present we have been exploring is temporal, open-ended, and self-conscious: would it not conduct, then, only to provisional, inconclusive aesthetic judgments? Yes, but rather than this constituting a failing, it crystallizes my reinterpretation of the ultimate point of modernist work. The tentativeness of our judgments of taste here, enforced by attention to the work's estranging and offering medium, links them to an overarching educational project. Modernist art and literature is worth supporting and advancing, I want to claim, because it fosters existential learning. It stimulates such learning, which necessarily takes time and reflection, with works that can never be exhaustively comprehended, works that constantly remind us of our existential ignorance, and of what is offered to us to learn to like and love. This does not mean that these works are merely didactic devices, that we have once more reduced art to rhetoric, for in this education there is no learning without the exercise of taste. This exercise may be inconclusive and thus unauthoritative, even idiosyncratic, but it nevertheless raises the question for each of us, crucial for our self-knowledge, of what attracts. Cultivating a taste for the Present in its manifold manifestations, and recognizing the ethical responsibilities implied by it, is what I call, in sum, learning presentmindedness.

By using this term to epitomize the aim of modernism's existential pedagogy, I am plainly inviting contrast with some form of absentmindedness. The next chapter will articulate this distinction in the process of reexamining the politics of modernism. Here, I have tried to complete my initial theory of how modernist art and literature can lead us to, and constructively from, the experience of existence, by explaining how it can help us overcome skeptical disorientation

accompanying the realization of our strangerhood. Fried's attempt to discriminate between modernist and literalist work ironically shows us how the latter clarifies and strengthens the affirmative point of the former, establishing how that point redeems our strangerhood. The modernist work, particularly in its literalist dimension, says yes to the Present and teaches us presentmindedness, why and how to cultivate the virtues of gratitude and generosity. However, if this is the case, if modernism fosters existential learning and this learning is as natural to us as breathing, stemming from our very being, then why is modernist art in desuetude and the learning practically unrecognized? Few care about existential learning today, especially professional educators. How could we fail to even notice what I am claiming is so close to us and crucial? If my view is not simply false, there must be some cause of this—a cause determined by, I contend in the next chapter, modernism's social context.

CHAPTER FIVE

Counterconsumerism

This might be a good time to review the principal steps of my reasoning so far. That argument was broached by the question of whether my declared culture of modernism, combining elements of traditional Western high culture with some of the countercultural energies I experienced in the seventies, has any importance for education today. To substantiate my intuition that it has, I began by theoretically demarcating a particular part of our education. Existential learning names the project of responding to the realization we exist by learning how we should live with that condition, rather than denying or neglecting it. I develop my idea of this learning out of a critical examination of Oakeshott's related conception of liberal learning. Oakeshott explains that to be human is to be free to understand oneself; this freedom, however, as Sartre points out, actually puts the possibility of self-understanding seriously in question. In order to save Oakeshott's conception, I try to revise it such that it is grounded on existence. This condition of ourselves and the world is for us essentially and irreducibly questionable; therefore, when we experience this questionableness, we are challenged to learn how we should live subject to it, to learn what would be a good way for us to exist. This challenge motivates us to develop a pedagogy suitable for cultivating this learning. What kind of cultural works can aid us in recognizing how a variety of experiences lead to the experience of existence, and in responding satisfyingly to that experience in a variety of practical ways?

The reason the modernist tradition is educationally important, I claim, is that it gives us guidelines for identifying one fount of such works. The idea of modernism I take up is that of Greenberg's, which distinguishes modernist from traditional artworks by the former's stress on the artistic medium. The burden is thus on me to explain how this mediumism theoretically conduces to existential learning. I find help in this task in work of two of Greenberg's leading acolytes, Clark and Fried. Clark acknowledges the importance of Greenberg's stress on medium, but contends that what this ends up expressing is political opposition. I concur with this interpretation of modernism as fundamentally negational, but deepen it by likening it to Sartre's account of the medium

of consciousness as nihilating. That modernist, mediumist works represent how our consciousness restlessly nihilates its objects, I argue, means that they capture how we are essentially strangers to questionable existence: they represent our strangerhood. They thus link the rich diversity of experiences registered in their mediums to the central experience of existence registered by the distinct fact of medium. If that were the end of the story, though, this existential learning, while showing how many, perhaps all roads lead to Rome, would leave us with no idea about how to do as the Romans, how to respond constructively to our strangerhood. This is why I next turn to Fried who takes issue with Clark; he tries to establish modernism's affirmational nature by contrasting the aesthetic quality of its works with the nihilistic objecthood of literalist work. I, however, discern in the latter an affirmation too, that of the medium's materiality, of the Present. Fried discloses, albeit unintentionally, that the modernist stress on medium can represent both who we are in the face of existence, our strangerhood, and what would be a good way for us to respond to this condition, presentmindedness. The key insights of his and Clark's accounts may thus be pursued into an argument that finally reconciles them and explains their pedagogical value.

Part of this reconciliation, I should add, involves a relaxation of the oppositions between representation, abstraction, and literalization. Mediumism employs all three of these modes of art and does not deny itself in the name of some notion of purity. It puts us in touch with familiar experiences of the changing world by representing them. It connects these experiences to that of existence by abstractly estranging us from them. And it finds in the experience of existence an opening to the Present by revealing that abstraction switches ambiguously into literal materialization.

The culture to which I understand myself belonging, then, is that formed by a conversation that examines various mediumist works for lessons in existential learning. I want to imagine this conversation taking place not only inside schools and other institutions of formal education but also throughout the public sphere. The mass media, the architecture of our living spaces, the design of our accessories, not to mention our art and literature: I envision all of these devoting a principal part of their energies to the cultivation of a communal self-consciousness about what it means to exist. Such a culture would draw on the legacy of the arts in order to fuel open, continuous, renewed discussion about who we are and what is important for us: discussion rooted in our most undeniable commonality, existence; sensitive to our diverse and changing circumstances; and calling for our participation and support.

Evidently, I have no compunctions about dreaming out loud. But the more I link my argument to such a utopian vision, the more I lay it open to the charge of being naïvely idealist. Why do I seem bent on ignoring the evident waning of interest in mediumist art among active artists and that art's virtually complete petrifaction into a pre-postmodern period style?[1] Who cares if the art

could facilitate existential learning if hardly anyone today is interested in the latter? And what does this finally say about a learning that is supposed to be as natural to us as existing? Whatever its attractions, unless my theory of modernism as a pedagogical culture of existential learning engages with the concrete, widespread, real disinterest in such learning in our present age, and in such art as a living practice, it will remain a piece of wishful thinking.

This, then, is the task for this chapter. Acknowledging that the above, double disinterest is potentially fatal for my theory's plausibility, I shall argue that it is in fact not natural, but has been artificially induced. A sketch of the apparatus of this inducement will link the prospects for existential learning and mediumism to their current social conditions of existence, and to the need to establish a more supportive context. This need broaches a political project, as I have repeatedly indicated, one committed to defeating consumerism.

IMMEDIATE ABSENTMINDEDNESS

Existential learning takes its first step with the realization of one's strangerhood. Yet who among us thinks of himself or herself as a stranger to existence? True, we are regularly invited to be entertained by the weirdest media fantasies, but we enjoy them precisely as flights from reality. And of course, when we visit or are transplanted to another land, we can feel terribly or wonderfully at sea. But regarding the way most of us actually live from day to day, the banal truth is that we treat the world as our home, and do otherwise only for exceptional reasons.

So my account of our basic condition must be wrong—unless I can plausibly explain how most human beings have somehow become so denatured that they no longer recognize who they are. Nor is it enough for such an explanation to be self-consistent: it must prove itself to be more practically satisfying for most of us than familiar common sense. Any revision of something as deeply entrenched as our at-homeness will not happen overnight; for that reason, we ought to treat theories that question this sense of comfort less as occasions for epiphanic conversion than as hypotheses that need to be gradually tested in the court of public culture. Accordingly, while I stand on the shoulders of the giants of the past "hermeneutics of suspicion" century, I do not share their occasional presumption that sheer imaginative ingenuity and far-outness can obviate the need to detail the concrete benefits of an alternative view to our everyday lives.[2]

I do not mind admitting that I hardly feel up to such a daunting project, one demanding the revolutionary imagination of a Rousseau. However faulty, his vision of how the social order entire could be transformed by education has never been matched for the detail of its criticism and the daring of its speculation. But if I cannot hope to squeeze an *Emile* into the confines of this chapter, let me at least try to sketch out the main protagonists of such an account, the rough equivalents to Rousseau's three primary forms of learning: education from nature, from things, and from men.[3] If in the process, I help revive interest

in his educational radicalism—one that surely has its grave shortcomings, most strikingly its unbalanced masculinism, but that should not be so quickly reduced to a mere historical ingredient of some Deweyan synthesis of nature and culture—that might add too to our resources for coping with our present cultural predicament.[4]

Let me start, then, by considering how we tend to understand ourselves today. At once, this becomes impossible to generalize. The question here is pointless unless I simply want to note, as I did above, that however one identifies oneself, one does not as a rule think one is a stranger to existence. That seems plain enough.

But we should be careful about exactly how we phrase this truism. It is not that one thinks to oneself, "I'm not a stranger," let alone convinces oneself that there are no reasonable grounds for believing oneself to be one. Rather, this way of understanding oneself never even occurs to most of us. Indeed, let me risk the following generalization: however many different identities are available to us to recognize ourselves in, to be addressed as, however many roles we are socialized to take up, "existential stranger" is not one of them. The latter is a missing piece in the cornucopia of possibilities.

It may still seem, though, that we are chewing over the obvious. Of course, there is no "existential stranger" because this category is negated as soon as it becomes a question of positively knowing oneself. As soon as I become interested in determining that *this* is who I am, I am prevented from taking seriously any notion I am *essentially* an enigma to myself. Our deep-seated assumption that everyone must possess some identity logically excludes the possibility of being an existential stranger from consideration.

Now the previous chapters have argued that this assumption is untenable. I can identify the personae I assume but not the being who does the assuming. I cannot know who I am distinctly, my characteristic traits; I can only know that I do not know, that I am not of this familiar world. My argument claims that these are central lessons of our essential, existential learning; the latter would be analogous to what Rousseau calls our education from nature, our normal realization of our humanity. It follows that it cannot be natural for us to stay oblivious to at least the possibility that we are existential strangers. What, then, accounts for this forgetfulness? This question asks for two kinds of explanations.

First, it challenges us to account for what could cause even a hint of our authentic condition to be suppressed. If this suppression is unnatural, then there would have to be some artificial pressure behind it—some denatured education from men, to employ Rousseau's terminology. Is there any evidence that we are being actively miseducated in such a fashion today?

Second, it asks what would be gained if the possibility of understanding ourselves as existential strangers were kept from view. Why on earth would we want to deny ourselves access to the truth of our condition? From what perspective might this be considered a good thing? Still more pointedly, whose

interest or interests could the ruling out of this possibility serve? The question of why strangerhood is for many inconceivable calls us to mind how someone or some party might find such thought blocking useful.

From the point of view of someone persuaded of our strangerhood, then, I am trying to account not for the opposing belief, but for a kind of absentmindedness in which opinions, let alone debates, about this condition are effaced. I have to explain what could cause us to look away from anything that starts to estrange us from the given world. Anything that reminds us of our uncertain and exposed being.

> Imagine any situation you like, add up all the blessings with which you could be endowed, to be king is still the finest thing in the world; yet if you imagine one with all the advantages of his rank, but no means of diversion, left to ponder and reflect on what he is, this limp felicity will not keep him going; he is bound to start thinking of all the threats facing him, of possible revolts, finally of inescapable death and disease, with the result that if he is deprived of so-called diversion he is unhappy, indeed more unhappy than the humblest of his subjects who can enjoy sport and diversion.[5]

What a marvelously contemporary note Blaise Pascal ends on here, as if he were jumping from feudalism to our age of channel surfing. The prophet of *divertissement* observes that even kings are troubled by their own shadow and require a means of escaping from their royal but mortal selves. For those of us who are unwilling to stand anxious reflection, to subject ourselves to existential learning, the only happiness lies in distraction. Pascal casts light ahead on one of the great secrets of contemporary consumption: we enjoy less the moment we incorporate the desired object into ourselves, than the moments we are absorbed by desire for the object—and so take leave of ourselves. Those who hold "that people are quite unreasonable to spend all day chasing a hare that they would not have wanted to buy, have little knowledge of our nature. The hare itself would not save us from thinking about death and the miseries distracting us, but hunting it does so."[6]

Our obliviousness to our existential condition represents the exact opposite response to our strangerhood from presentmindedness: rather than acknowledging our condition and seeking to orient oneself to the good of it, the Present, the absentminded reaction here is to notice only that existence has no bearing on how things are in one's world and thus is not worth attending to. Following Pascal, I attribute this reaction in the first instance to our fear for the security of our being, a psychological state; realizing we exist is realizing that we are thrown into and shall be thrown out of being, and that we cannot have any firm control over that. A second cause is the availability of diversions, a state of our society. The psychological fear is perfectly natural and continuous with the "ordeal of consciousness" and the challenge of

existential learning: it is a formidable barrier, but we can develop the will to overcome it. What seriously dissipates us, though, is our environment of predatory distractions.

Comparable to the way modernization's waste has been attacking our bodies and the planet's health, its cultural waste has been scattering our minds. Everywhere we turn and at every instant, there is a spectacular event in the media, a new bit of information, that exacts notice. Even though most of these can hardly hold or reward our attention, they nevertheless serve and satisfy as vehicles for temporarily escaping reflection—until we are diverted by the next fragment in the chain. As Adorno and Max Horkheimer already noticed of movies back in the days before MTV, "They are so designed that quickness, powers of observation, and experience are undeniably needed to apprehend them at all; yet sustained thought is out of the question if the spectator is not to miss the relentless rush of facts."[7] The only thing wrong about this description is that it overestimates the degree of control the spectator has over the desire "not to miss the relentless rush of facts." The mechanism here not only fails to muster but positively captivates the will we need to face our existence; the above desire supplanting this will is not our own. Far from learning how to be ourselves, we are possessed.

That the mass media has not exactly stimulated serious education of any kind among its audience, that it tends to turn all it touches into entertainment, is to be sure stale news. What is worth emphasizing for our purposes, though, is that these diverting powers inhere less in any particular content than in a specific form. If we are concerned about how TV programs distract us from self-reflection, from even the first steps of existential learning, then we should acknowledge that this can be accomplished just as well by biopics of intellectuals as by clips of pet tricks. What counts is that the content, regardless of its nature, be presented in such a way that, as Adorno and Horkheimer suggest, moments of sudden, disruptive eventfulness are intensified but meaningful connections to us played down.[8] I have to be presented with enough novelty that my curiosity, even apprehensiveness, is aroused, but I also have to be distanced enough from the event that nothing about it reminds me of myself or my condition. My mind has to be seized and spirited away from attending to itself and the Present.

What is the most efficient form for accomplishing this? One that conveys the strongest sense of immediacy. The more the work enables us to feel that we are *there*, as if in the blink of an eye we had been whisked to some other scene, the more irresistible its diverting power. Because we may be tempted to associate this effect simply with electronic technology, suppose we consider an example from painting. Here is Greenberg describing an "ignorant Russian peasant" looking from an icon to a work by the nineteenth-century painter, Ilya Repin, and taking a special kind of pleasure in the latter.

He turns next to Repin's picture and sees a battle scene. The technique is not so familiar—as technique. But that weighs very little with the peasant, for he suddenly discovers values in Repin's picture which seem far superior to the values he has been accustomed to finding in icon art; and the unfamiliar technique itself is one of the sources of those values: the values of the vividly recognizable, the miraculous and the sympathetic. In Repin's picture the peasant recognizes and sees things in the way in which he recognizes and sees things outside of pictures—there is no discontinuity between art and life, no need to accept a convention and say to oneself, that icon represents Jesus because it intends to represent Jesus, even if it does not remind me very much of a man. That Repin can paint so realistically that identifications are self-evident immediately and without any effort on the part of the spectator—that is miraculous. The peasant is also pleased by the wealth of self-evident meanings which he finds in the picture: "it tells a story." . . . The icons are so austere and barren in comparison. What is more, Repin heightens reality and makes it dramatic: sunset, exploding shells, running and falling men. . . . Repin is what the peasant wants, and nothing else but Repin.[9]

It is clear a modernist is scarcely going to be friendly to such kitsch, hence the tendentious association Greenberg draws between Repin and peasant taste. Today, of course, such provocation is apt to backfire; rather than being intimidated by the connoisseur, we are liable to dismiss the snob. In any case, in our argument, issues about viewer competence need have no bearing on how this work's form produces certain effects even on those who sneer at them.

That form's chief characteristic is its occult technique. Unlike in a Picasso, to which Greenberg compares this picture later in his essay, the medium here withdraws into invisibility; the spectator is not invited to give a second thought to conventions, let alone to the paint's, canvas's, and frame's materiality. Instead, he is impressed by "the vividly recognizable, the miraculous and the sympathetic." The work's vividness, its new, surprising leap forward in verisimilitude, enhances what is presumed to be extraordinarily meaningful and dramatic about a particular event in the world outside the picture and our situation, allowing this event to touch us. A novel naturalism, paradoxically enough, translates into a break from the everyday. This technique sharpens particular qualities of the event, arousing our sympathy for them. For this to happen, however, the gist of the event, the picture's subject matter, must be easily recognizable. How could we judge a work to be successful in these terms if it conveyed only the impressionistic qualities of an unfamiliar event, such as that of our being?

No doubt the most compelling of the effects listed above is the work's miraculousness. Again, this is a function of how well it cloaks its medium. It is amazing that this painting can carry me away from my situation to this distant world more alive, a miracle of smoke and mirrors. In my after-work fatigue, this piece simultaneously relaxes my faculty of understanding while stimulating my capacity to be sentimentally moved. The less interpretive effort is asked of me,

indeed positively put out of place, the more admiring I am invited to be of the medium's might. Without lifting a finger, this power instantly transports me. As we progress from painting toward our digital media, from the kitsch Greenberg was contemptuous of to harbingers of the Matrix, the power that impresses us draws on billion-dollar conglomerates; consequently, our appreciative wonder, Adorno sardonically points out, flows into a salute to this money as well.[10] In any event, generalizing from Greenberg's example, we can hypothesize that works whose forms project immediacy by hiding their mediums are motivated by our desire for diversion.

Of course, this "immediacist" form has grown much more sophisticated since Greenberg's day. What is lacking in the Repin example is the capacity to shape the experience of time. Today, I would say that temporal fragmentation rivals progress in verisimilitude as the chief means for maintaining our current environment of DeLilloesque white noise. Our thirst for the startlingly new and distracting is apt to be quenched, and rearoused, more by works, or channels, that overwhelm us with the sheer quantity of their disjointed bits of information than by works of increased digital detail. In this stream of discontinuity, the coherent substantiality of the subject matter ceases to be a ruling concern; all that matters is that the disintegrating atoms are facile enough to be instantly recognized and to grab our attention. Kant's straining imagination of the mathematically sublime, Wilhelm DeKooning's "content is a glimpse": who could have guessed how prescient these concepts would be of our dysfunctional nervous system of communal diversion.

Immediacy is transporting force, and transport in this sense, I am arguing, is flight from our authentic condition. The work of immediacy, produced by concealment of its medium, fosters absentmindedness. Opposed to this, the mediumist work exposes us to our strangerhood and opens us to the Present. These two kinds of work, then, pit a culture of existential learning against a pseudoculture and anticulture of determined ignorance.

So what is the reason for the moribund state of this learning and mediumist art? It would seem to be that our interest in existential bad faith is stronger. To conclude this, however, would be to surrender to the notion that human beings are ruled predominantly by anguish, anguish over their free existence. This is not an unreasonable view, but I refuse to accept it. I do not want to discount considerable anxiety about my exposed, estranged being, but just as history is largely the story of human beings gaining control over their fears, so I am confident there is a way to master this sentiment. Nevertheless, it is hard to believe we can have gotten very far when one surveys the vast, global blanket of distractions we are clutching. If this apparatus is not fueled by a terror so preoccupying it must be unconquerable, then what else could be motivating its relentless expansion?

The answer resides in the relationship we usually think of ourselves adopting toward all things on offer in the mass media: we take ourselves to be consumers of them. Put the other way around, these media constantly address us—interpellate

us, in Louis Althusser's sense—as purchasers of fun: no matter what is on, it is surrounded by commercials, and what is on is something that has been advertised as well.[11] These refrains reinforce a sense of who we are supposed to be and what we are supposed to care about. And this ethos of consumption would lose its celebratory, sunny, jinglish ring if it meant primarily having to pay for shelter from the menacing unknown. It makes sense that we media consumers do not understand ourselves to be running away from our condition; as Sartre explains, it is a contradiction to imagine someone in bad faith deliberately concealing something from himself or herself.[12] We are simply looking for a bargain.

How, then, should we comprehend the relation between "consumption" and "diversion"? To some degree, they are the same thing. The pleasure consumed, I suggested earlier, *is* that of diversion, of relief from existential anxiety. But it is also something else; this pleasure has a meaning that is separate from—and that thus really does steer us away from—the question of existence. It is our reward for otherwise unfulfilling toil. We are able to resign ourselves to labor that is dispossessed of its products, labor whose intrinsic sense of purpose belongs to someone else, because the extrinsic compensations divert us as well from our pointless exhaustion. Indeed, we become used to the notion that nobody in their right mind would work were it not for the play that comes afterwards; we accept that a job is necessary pain for after-hours gain. To fight for essentially satisfying work, for cooperative dispositions that would replace wage competition, then seems quixotic. And we know whose interests *that* would serve.

Earlier, I described how the mass, commercial media establishes a relationship to us in Althusserian terms; it interpellates us. This characterizes this media as an apparatus of ideology. Such an apparatus encourages us to think of ourselves in one way, as individual agents freely commanding a certain amount of purchase power and the potential to acquire more, while disciplining us to behave in another, as interchangeable members of a class determined by an exploitative mode of production. This consumerist ideology helps reproduce the capitalist social order by easing us into our functions and mollifying our protests. I think this picture is more or less right, but I would want to emphasize something that has become much clearer since Althusser wrote. This media's ideological interpellation does not amount primarily to the implantation of certain beliefs in us, or even to their censorship. Although the commercial media spews out explicit as well as subliminal suggestions—don't you want to buy this, wouldn't it be too much to tolerate that—it does not demand we turn these notions into convictions. It has moreover shown itself capable of accommodating the most iconoclastic images and ideas. Why this insouciance about what we think if its goal is ultimately social control? The reason is that it principally works, once more, through diversion. In a state of information overload, and consequently indecision, I am most likely to follow the path of least resistance, even if I am derisive about its apologetic accompaniment. Similarly, Abu Ghraib or Darfur has to share the stage with Lindsay Lohan for their fifteen minutes before they

are hustled off by the next breaking scandal; unable to constitute a sustained center of attention, none of these is apt to faze me. To keep us from concerning ourselves with how we are becoming habituated to certain practices, ideology does not have to rely any longer on questionable dogmas—simple dispersal of the will is effective enough.

Even if it is a stretch, therefore, to conceive of people so adept at lying to themselves that they can manage, as if sleep walking, a world-network of diversions, it is much less implausible for us to theorize a pseudoculture that is overdetermined by the ruling interest in consumption. Our hypothesis about what motivates works of immediacy may be modified accordingly. The commercial media does turn us away from our strangerhood, does instill absentmindedness, but that is actually a byproduct of its chief purpose. It exists to promote consumerism as a way of life, as the good. It teaches us how to be savvy shoppers and discriminating gluttons, hypnotized by the market of possibilities flashing around us; it cheerfully reassures us that fun redeems the miseries and precariousness of the work station. We learn to understand work principally as a means to buy, not as the prostitution of our talents. Because this media, this ideological apparatus, so comprehensively modifies our behavior, then, it educates us in a fashion. But insofar as it prevents us from reflecting on who we authentically are, stifles our existential learning as well as any critical perspective on our relations of production, it represents something more like drone management. How far we have come from kitsch being merely an insult to our intelligence.

As long as we remain subjects of this regime, it is no surprise that we would be disinclined to engage in existential learning. Support for the latter practice, therefore, must include resistance to the former order. The freedom to understand ourselves has to be backed up by freedom from diversion; the battle against ignorance is also one against mystification. Now in Rousseau's great epic of countereducation, what supports our authentic education from nature and opposes, particularly in childhood, the misleading education from men, is an education from things. Aiming to enhance the natural growth of Emile's faculties, Jean-Jacques shelters Emile as much as possible and for as long as feasible from the opinion of others, and encourages him to learn from his own direct experience of natural objects in the world.[13] Analogously, to cultivate our existential learning, I want to argue, we need to find respite from the consumerist media and learn from our experience of a special class of pedagogical works. Indeed, respite is an unnecessarily timid goal. What a plus it would be if mediumist art had the power not only to foster present-mindedness on the run but also to inspire us to struggle concretely to establish a preserve for it.

A FUTURE FOR "ELIOTIC TROTSKYISM"

For existential learning to thrive today, a social context hostile to it must be changed. Its supporters would have to win room for its cultivation by rolling back the consumerist occupation. Moreover, we should not naïvely think that this can be achieved simply by rationally discrediting forms of immediacy. Even if the party of consumerism dare not laud these forms' diverting power, it can effectively play down that "side effect" so long as it commands the public's inattention with its overwhelming resources. As I write this, neoliberalism is in the fourth decade of a sweepingly victorious offensive. It is tough to discern anything on the horizon that might turn the tide on its ruling class or the hegemony of its consumerist pseudoculture.

Mediumism alone, it goes without saying, cannot be such a challenger. When push comes to shove, and police intimidation is brought into play, most people who can afford to engage in existential learning will realize they have too much to lose. Ellen Meiksins Wood's arguments about the centrality of the impoverished working classes to any realistic resistance to capital appear unanswerable.[14] But mediumism can help broaden and deepen this resistance by exposing how our humanity is being held hostage on the cultural front as well. Just as ecologists have sounded the alarm about our biosphere's health, so mediumists can militate for attention to our cultural environment and its capacity to sustain existential learning in the teeth of consumerist pollution. Addressing both of these environmental problems with any degree of seriousness will entail engaging with the antagonistic interests of those who are content to profit from them. Such clashes will ineluctably ally those devoted to these concerns with the exploited, thus creating an opposition that speaks not just for more humane labor and stewardship of the planet but also for more human learning to rise to these responsibilities.

Politically and theoretically speaking, then, mediumism can be considered anticapitalist cultural environmentalism. But is it really suited to this role in practice? Now that kitsch industries have metastasized into orbiting telecommunication systems, the tradition of "Eliotic Trotskyism" can seem more quaintly irrelevant than ever. Not to mention, as Clark explained, hopelessly contradictory. Whoever still recognizes some kind of kinship with the revolutionary will probably abhor everything T. S. Eliot stands for. Such radicals will be suspicious of how claims to superior taste tend to take for granted enabling, unequal conditions of leisure, education, status, and so on, just as traditional high culture in general presupposed an aristocratic order of privileges and liberties. How small a step it is from assuming such conditions to calling for a restoration of traditional hierarchies, as Eliot did when he avowed royalist sympathies. In the spirit of Pierre Bourdieu, then, they will be inclined to associate aesthetic discrimination with exercises in social distinction and exclusion, to the point, following Serge Guilbaut, where they may describe the significance

of a nominally aesthetic movement like modernism in terms of its effectiveness as a Cold War weapon.[15] Conversely, the revolt against "the canon" has created its share of defiant, ostensibly conservative aesthetes who, like Harold Bloom, associate social criticism directed at literature with the revenge on talent of *ressentiment*. Bloom contends that those who can, struggle to say their own, original word about our experience; those who cannot, politicize.[16] Thus if the names of Eliot and Leon Trotsky can still mean anything today, do they not stand for the diametrically opposed poles of what has become a tedious "culture war"? Should we not free ourselves of this tiresome heritage with one stroke of the postmodernist sword?

To defend the modernist tradition against these doubts, I would need to establish the critical salience of each of its two sides and their coherent recon- cilability. I would have to explain how the same features of a mediumist work that stimulate existential learning also, in Eliotic and Trotskyist ways, raise our consciousness about threats to it.

Let me start from the side of the aesthetic. As we saw in the previous chapter, Fried has argued that modernist works strive for the heights of the old masters; the beauty they succeed in attaining, relative to this exemplary tradition, gives them their affirmative power. I have endorsed this under- standing, extending it in particular to the work's materiality. Now I want to emphasize the contrastive power of this affirmation. The mediumist work of traditional beauty, celebrating presentmindedness, stands out, not only more or less from its peers that share the same aspirations, but also much more strik- ingly from works of entertainment that evince little interest in this beauty altogether. Often, we know, this contrast has been defused by turning it into one between high and low culture, between the elite and the people. But for existential learners, maintaining the aesthetic significance of the disparity is crucial because they grasp that consumerism can never be genuinely populist so long as it starves our universal learning. They insist on the importance of seeing that consumerist works, compared to their mediumist counterparts, are less responsive to aesthetic standards than commercial and ideological calculations, of noticing how immediacist works fail to register our various experiences, especially the central experience of existence, with anything like the level of accuracy, detail, and insight reached by the best art of the past. Only by facing evidence of such cultural decline are the rest of us likely to become alarmed at what consumerism is costing us. Without this yardstick, such criticism would lack historical grounds and could be disarmed by blithe appeals to a timeless, complacent relativism, where individuals in different circumstances just like what they happen to like. With it, these aesthetic stan- dards may take on a new life beyond their former one as pillars of aristocratic eminence. There is no necessary reason why values that were historically ruling-class, or restricted by gender, race, ethnicity, and so on, must remain so.

Even if some people continue to use them as flags of reaction, we can add to our denunciations of such abuse arguments that they can be more vitally put to work in our situation to measure how cold society has turned to existential learning and how urgent it is that we do something about our current ruling order of enforced existential ignorance. For this reason, I would once again revise Fried's position in order to underscore that mediumist works strive not only to put themselves in the company of the canon but also, as it were, to steal the latter's fire and hold it up to the present's cultural pretenders.

Some readers may protest that I have gone overboard in dismissing the achievements of popular culture, that my modernism sounds like nothing but prissy mandarinism. *The Wizard of Oz*, episodes from *The Twilight Zone*, "Sheena is a Punk Rocker": how easy it would be to assemble a list as long as one likes of hits that are also masterpieces. But this would miss the point. Although I have been deriving a concept of consumerism from my of course limited experience of works in the commercial media, I want to insist on that concept's principled generality and its lack of assumptions about what specific works must fall under its provenance. In other words, I precisely do not want to presume in advance that a certain Hollywood movie, let alone a whole genre of pop music, must be classified as nothing but consumerist; I would expect the category to be used to stimulate close examination and considered judgment of the particularities and hybrid quality of such works. In the Bee Gee's songs on *Saturday Night Fever*, for example, there is something in the disco beat that is unexpectedly, and not simply immediately, moving. Plenty of other works that privilege commercial success over aesthetic truth end up transcending, to some degree, the limitations of those designs. This does not mean, though, that those limitations and their stunting effects on us are not serious. To reiterate, in the final analysis the point is not to identify works that we the elect can unite in scorn of, and so to pronounce on the culture of others. It is to help us all make sense of some of our own experiences of dissatisfaction and disorientation in a situation of decadence. Which works get categorized as which is less interesting for my purposes than better comprehending our cultural predicament.

Let us return, then, to the idea that a successful mediumist work can draw critical attention to consumerism by virtue of the marked contrasts it establishes. I have argued it achieves this in an Eliotic way when it appeals to traditional, high-cultural aesthetic standards that commercially and ideologically motivated, consumerist works do not, as a matter of fact (which must be empirically established on a case-by-case basis), match. Can it accomplish this as well in some construably Trotskyist fashion? Yes, if we associate the prophet of revolution generally with a vigilance for the dialectical possibilities in cultural as well as social decline. Along these lines, Fredric Jameson succinctly explains the "hard lesson" Marx offers us in the *Manifesto* of "some more genuinely dialectical way to think historical development and change."[17]

The topic of the lesson is, of course, the historical development of capitalism itself and the deployment of a specific bourgeois culture. In a well-known passage, Marx powerfully urges us to do the impossible, namely, to think this development positively and negatively all at once; to achieve, in other words, a type of thinking that would be capable of grasping the demonstrably baleful features of capitalism along with its extraordinary and liberating dynamism simultaneously within a single thought, and without attenuating the force of either judgment. We are somehow to lift our minds to a point at which it is possible to understand that capitalism is at one and the same time the best thing that has ever happened to the human race, and the worst.[18]

Accordingly, Jameson urges us to apply that lesson to our time, and "think the cultural evolution of late capitalism dialectically, as catastrophe and progress all together."[19]

I have been devoting considerable attention to the catastrophic aspect of consumerism. What could be its progressive side? More specifically, how might it prepare the way for a divergent, countervailing movement powerful enough to topple it while holding on to its advances on its predecessor? The answer must lie, as anyone acquainted with the principles of judo would expect, in consumerism's very strengths. This pseudoculture is most effective at assembling a mass audience and stimulating their fantasies of escape, thereby reinforcing their real captivity. Yet this audience has for the most part no hand in constructing this culture and thus exists unrepresented by and materially removed from it. If the audience were to awaken to the possibility of seeking escape in actuality, of actively opposing this foreign social order and liberating themselves from it for the sake of building a better, peacefully enduring one, then perhaps we could talk about dialectical progress. The trick to get us to this point would be finding some way of turning consumerism's assertive powers of assembly and escapism against itself. Some leverage to place in its path.

Imagine cultural works that were designed to inhabit the mass media and address a mass audience. Imagine that they affirmed, sometimes even hyperbolically, the prevailing interest in escape. But imagine too that they linked that escape to a disclosure of what we are escaping from, and of how our neglect of these problems will only entrench them. Such works would aim to capture and go with the power of typical consumerist works, but unlike the latter, they would reveal the contradiction consumerism is distracting us from and the suffering it traps us in—unless we turn toward avenues of action.

Mediumist works, I am suggesting, although distinctly limited in their capacity to organize such concrete, political avenues, can be useful in flipping the escapist powers of consumerism. As we have seen, the fundamental basis of these powers is the illusion of immediate transport; the first thing we are invited to escape from is any awareness of the medium. Mediumism's negation of that illusion and its imperative to acknowledge its conventions and materials must therefore raise questions about work that prefers to hide these. Such questions

would be posed most directly by mediumist works in the main consumerist media rather than in the traditional fine arts, works that solicit the usual expectations of that media only to expose what they are covering up. Why might someone want to conceal a consumerist work's conventions and materials? What does this concealment enable? What kinds of rhetorical effects? And what else may be secreted in the work that interlocks with its medium, spurring the impulse to escape in the first place? What politico-economic infrastructure? Such questions broach the critique of immediacism and its capitalist interests elaborated above. They raise the possibility of real escape.

Here too we can be nuanced about the case of pop art. Warhol, Roy Lichtenstein, Claes Oldenburg: these artists did not just childishly reproduce commercial iconography; they stressed the media of these images in beautiful, and critical, ways. For every interpretation of them as camp enthusiasts or cynical antiartists, there is an equally plausible, more instructive one according to which they sound the pathos in the tinsel our culture has become. A capacious modernism that is no longer discomfited by their departure from abstract expressionism can easily claim them as its own.

Mediumist works expose immediacist ones to critical scrutiny with regard to their political as well as profit-making interests. This does not necessarily mean, though, that the former will feature political dramas or directives, or confidently point out friends and enemies. Its aesthetic concerns must not take a back seat to propagandistic ones. In the same spirit as Trotsky's animadversions on *Proletkult*, a group that agitated for proletarian purity in early Soviet culture, I have serious reservations about any dismissal of artworks on political grounds.[20] My theory's argument summons us rather to a politics that aims to be, to put it crudely, aesthetically, educationally correct. Not the revolution but existential learning is the ultimate goal of mediumist art; however, to reach it, the revolutionary overthrow of the pseudoculture capitalism forces on us is key. A politics that forebears harnessing art but instead harnesses itself to the releasing of art, as well as to *all the other emancipations that would be a necessary condition of this*: such is what I would call a mediumist "Trotskyism."

At last, I am in a position to come back to one of the central points in dispute between Clark and Fried: whether modernism should be concerned purely with aesthetic value. Here also, on the basis of this chapter's critique of consumerism, I would like to posit a kind of synthesis. On the one hand, as discussed above, we can affirm with Fried that modernist works aspire to the values exemplified by the best art of the past, such as those of registering experience with nuance, precision, power, complexity, a sense of the whole, and so on. Yet it would be no compromise to hold too, with Clark, that this very aspiration puts such works in conflict with our current social order; to pursue the aspiration, then, is to express and stir up the opposition. Setting aside the misleading issue of purity, this theory of modernism argues that in this historical moment a concern for aesthetic value *is* a political concern with

consumerist capitalism. The former should not be separated from the latter; the latter should include the former. The latter especially directs mediumist art to resist one common form of accommodation: that of being employed to dress commodities in hipness.

Modernism is a culture for existential learners and against our inter-pellation as consumers. It encourages us to respond to our strangerhood by cultivating presentmindedness, rather than to flee knowledge of that condi-tion into absentmindedness. It consists of artworks that are more concerned about measures of beauty than box office, that stress their media, and those media's political implications, instead of projecting immediacy. It invests these works with both an aesthetic and a political imperative. These are the central, contrasting lineaments of my theory: specific examples of works that support it would have to exhibit these characteristics. In the next chapter, I shall broach the project of testing the extent to which this theory covers actual work, rendering that work useful for existential learning. Evidently, this is a project that calls for much more study beyond this introductory book. In the meantime, I hope I have at least sketched out an explanation of why our existential learning is being suppressed, and how resistance to this could breathe new life into the modernist project, a project that was sparked in part by the threatening spread of kitsch pseudoculture that has hardly abated. Before I conclude here, though, I should turn at last and more directly to the question behind this book's title. Might there not be, at this late date, some more informative and fitting appellation for the kind of art I have been discussing? What is still modern about modernism?

My motive for beginning with the term is easy to guess. Whatever the complications raised by Moretti in my introductory chapter, the fact is that "modernism" conjures up for most a relatively familiar and stable body of work. Despite the tricky and controversial cases, we generally have a good idea of who are the chief modernist artists and there exists a respectable critical tradition devoted to exploring their works. Thus I counted on the term designating a recognizable object of study.

However, as I progressively revised how I think modernism should be understood, I have admittedly distanced this object from anything necessarily "modern." The more profound, philosophical significance of the modernist medium, I have been arguing, is that it directs and encourages us to learn from existence. Existential learning is by definition a practice that occurs throughout all of human history; it is hardly anything new or necessarily endemic to situ-ations shaped by modernizing forces. Have I not arrived at a modernism, then, that is self-contradictory?

This is why I favor replacing the term with "mediumism." My reconstruc-tion of modernism has led me to see that for the purpose of fostering existential learning today, mediumism defines this body of work less misleadingly. Of course,

in order to stay in conversation with the discourse around this work, I am happy
to continue to alternate between the terms for the foreseeable future.

Notwithstanding this, however, there is one modern feature of mediumism
that should still be accentuated. I do not think it is as determinative as the
concept of medium for this body of work, but it must not be overlooked—not
if we appreciate that existential learning today, far from taking place in a space
surrounded by merely mildly resisting ignorance, is under constant threat from
a much more powerful force. To survive at all in this conjuncture, existential
learners have to fight back. Nothing could be more valuable for its militants
than works that mobilize opposition in the name of the cause of this learning.
Much as Althusser once conceived of his philosophy as drawing useful battle
lines between idealism and materialism, ideology and science, so I would
like my philosophy of mediumism to aid the struggle for existential learning
by demarcating its conflicts with modern consumerism.[21] Responding to the
appeal to intervene in these conflicts, then, entails affirming that one lives
in a contradictory conjuncture in flux whose resolution remains very much
undetermined, open to the difference resistance can make. Mediumists ought
to be modernists in the way they live their time.

In his marvelous paean to modernism, Marshall Berman emphasizes
again and again the ambiguity and ambivalence of the movement's defining
experience: we feel excitement and hope that a better future is taking shape,
and worry and anger that a precious past is being lost.[22] As the dialectical
art of this experience, modernism is self-consciously caught up in a time of
transition, a time that could be ours. These days, it has become fashionable
to accept that in the developed zones at least, the important transitions
are over; we have basically reached an end state. The postmodern period is
one when the more, the faster, things change the more they stay the same;
postmodernity is an experience of knowing ennui, ennui relieved by know-
ingness. Only a fool would deny the perception behind this attitude—but I
wonder if a little optimism of the will is not in order. To have faith in the
possibility of real, positive change informed by incredulity about spectacles
of pseudochange would challenge us, I find, to look for signs of passage, not
in the progress of contemporary developments, but in prophetic analogies
between the next world our contemporary one is trying to give birth to and
a discontinuous past. I am thinking here of Mark Twain's reputed saying that
history works in rhymes, and how this echoes Walter Benjamin's conception
of a history made in jumps. "Thus, to Robespierre ancient Rome was a past
charged with now-time, a past which he blasted out of the continuum of
history. The French Revolution viewed itself as Rome reincarnate."[23] The
rhyme of Roman republicanism with Jacobinism, and the contrast between
both of these and the *ancien régime*, gave Robespierre an image of what a
determined stride toward utopia, accepting the present as opportunity, would

have to look like, an image repeatedly and beautifully captured in paint by Jacques-Louis David. Accordingly, my hope is that a theory rooted in what now seems to many like ancient history, in a distant time of experimental and revolutionary aspirations that has to be deliberately recalled because it can be scarcely imagined, may serve as a memory that "flashes up in a moment of danger"—this moment that is threatening to distend into a long postmodern, cultural sleep.[24] That mediumism is no longer current endows it at present with an interruptive power.

Awake now.

Examples

For the purpose of existential learning, of cultivating our understanding of what it is like to exist, we are interested in pedagogical works that possess certain characteristics. They should show us how commonly recognizable experiences may lead us to the central experience of strangerhood, and why this path, even when it deviates from practical concerns, can nevertheless compel with the force of necessity. They should also illuminate how this experience, while disorienting, opens us up to the offer of existence, the Present, and so invites us to respond by practicing, in our own distinctive situations and manners, the virtues of presentmindedness. How would these works be capable of achieving these effects? By stressing their mediums in the spirit of modernism. Such artworks would disclose both how their mediums estrange us from the experiences they represent and how they draw attention to what is beautiful prior to any work.

In the last chapter, I started to imagine how a culture composed of such works, stimulating a conversational community of existential learners, could be incarnated in our public media, architecture, product designs, and so on. But I quickly acknowledged that this is a utopian vision far away from our actual situation. Today, few care about this learning or mediumist art. Such indifference is hardly surprising considering we are subjected to an apparatus that keeps us in a state of absentmindedness. A culture that is truly for existential learning, one based largely in the remaining places devoted to liberal education, would have to be at the same time a counterculture quickening resistance to our hegemonic, consumerist pseudoculture. How could its works accomplish this? By defending standards of aesthetic quality, they would mark what is lacking in works of mere diversion and by insisting on acknowledging their mediums, they would cast suspicion on works that disguise their supporting conditions. Although it is beyond naïve to think that such works alone could overthrow consumerism, they would at least offer us a crucial political lesson: if we recognize ourselves as existential learners, then we must recognize ourselves in addition as having a crucial stake in what capitalism is doing to our culture.

I have cast the above summary in the subjunctive tense because it remains to be seen whether there really exist works that even partly fit these theoretical criteria. To begin to identify some that do, I propose to look to contemporary cinema. A number of factors are motivating this choice. The first is that given the suspicions I have repeatedly evoked that there is something outmoded about mediumism, I would like to find counterexamples that are no more than 15 years old from the time of this writing. Second, as I noted in the introductory chapter, given that I have developed the theory largely in conversation with visual art critics and historians, it is important to test it against works of other art forms in order to determine whether it can actually provide guidelines for a comprehensive culture. Finally, cinema is particularly attractive because it is one of our central media of diversion: few ideological apparatuses can rival the power of Hollywood. Drawing attention, and hopefully support, to a mediumist cinema might constitute one small but meaningful way of challenging our consumerist occupation.

Before we proceed, we might want to reassure ourselves that it makes sense to look for modernism in cinema. Despite the fact it is not unusual to see films being characterized as modernist, Clark has raised a serious question about this usage.[1] He points out that although film resembles painting in consisting of matter coating a flat surface, unlike painting, it has proved unable to stress that surface and those materials in any impressive fashion. Only very rarely is a talented filmmaker like Stan Brakhage inspired by the example of painterly abstraction. I believe Clark is right and so would agree that modernism in this sense does not appear to be a promising avenue for cinema. However, his characterization of the material dimension of the cinematic medium neglects two other crucial ingredients: light and—since the rise of the talkies—sound. With regard to the live-action film, a central element of its medium is a configuration of light and sound emanating partly from a production studio but mainly from a theatrical set. In contrast to the materials of a painting that exist independently from the world represented in the artwork, the stuff on the celluloid is essentially a trace of the objects caught by the camera and microphone; that trace is an automatic, chemical effect prior to any artistic work. Thus how this registration of the light and sound of bodies and things on a set evokes, and resists, the imagination of an event in a story constitutes, I find, the requisite materialist side of film that would be mediumist.

In our search for examples of such film, we may be encouraged by the existence of a recognized yet ill-defined tradition of cinema that supposedly proceeds from less-than-fully-commercial values. To call a work an "art film" is often to claim or warn that it is interested in something besides entertainment. Yet what this interest exactly is, and how it departs from entertainment, are obscured by the unhelpful term "art." (A similar charge could be leveled at the "Great Books.") One thing to which an exploration of mediumist films might contribute is the replacement, if only partially and piecemeal, of the category

of art film with one, or more likely several, that are more precise and constructive.[2] Not all art films, I suspect, will turn out to be mediumist, but those that are will be more usefully characterized by the latter term.

Four works will serve to exemplify mediumist film for now: Abbas Kiarostami's *Taste of Cherry* (1997), Hou Hsiao-Hsien's *Café Lumière* (2003), *Rosetta* by Jean-Pierre and Luc Dardenne (1999), and *Ulysses' Gaze* by Theo Angelopoulos (1995). My focus will be on how these films can foster our existential learning and resistance to consumerism by stressing particular features of their medium, and thus serve as promising works of assigned study for teachers in liberal-education settings. All of them broach deep questions about what it means for us to exist that have no conclusive answers, and do so in ways that clearly depart from, and illuminate the aesthetic and political limitations of, elemental conventions of entertainment cinema.

TRANSPARENCE AND OFFSCREEN IMAGINATION

Mr. Badii, the central protagonist of *Taste of Cherry*, is on some kind of quest. The film's opening shot shows him seated in the driver's seat of a moving car, gazing intently out of the passenger's side window in our, the spectators', direction. When the car intermittently stops, men on this Tehran street come over to ask him if he is looking for laborers, but he shakes them off. At this prologue's end, however, after engaging an indigent gleaner in conversation, Badii asks if he would be interested in doing some well-paying work for him. The gleaner demurs; he is evidently disturbed by something in Badii's manner or face and does not want to hear anything more of this mysterious job.

The main body of the film consists of three dialogues with others to whom Badii offers the job. It turns out that what Badii wants to pay them for is to check on him the following morning after he plans to kill himself with sleeping pills. He will be lying in a hole on the outskirts of the city; if he is still alive, the person should help him up, if dead, the person should bury him. The first person to whom he broaches the idea, a Kurdish soldier young enough to be his son, reacts with revulsion and not only refuses but flees Badii. The second, an Afghan seminarian closer to Badii's age, listens with more equanimity but then explains that suicide is forbidden. Finally, the third, an older Turkish taxidermist named Mr. Bagheri, reluctantly agrees to do what he is asked because he needs the money for his sick son. Nevertheless, he spends most of his time with Badii trying to remind him of the taste of cherries, of what he would give up if he turned his back on life. Badii, however, is unimpressed; in the evening, he leaves his apartment and takes a taxi to the appointed spot. The last image of this story, that of Badii's face lying inside the hole, looking up at the night, fades to black and the sound of rain dwindles away. After a brief interval, the sound of marching soldiers fades in, and we awaken, as it were, to an epilogue of grainier video images. These are of the film shoot, including

one of the actor playing Badii walking over to offer Kiarostami a cigarette. The film ends with the relaxing soldiers playing with flowers as Louis Armstrong's version of "St. James's Infirmary" comes on the soundtrack.

A core question for those of us who find ourselves even mildly interested in the film is, what interests us? Although it is settled only later in the narrative whether Badii finds someone to help him and whether he goes through with the suicide attempt—we do not learn, though, whether he succeeds—these events are accompanied with little suspense or resolving force. They have no deadline and occur at quite a languid, desultory pace. Moreover, they do not bear on a character about whom we have been encouraged much to care. Beyond Badii's anxious desire to find someone to assist him, we know virtually nothing about this middle-aged man or what might have brought him to this pass. He appears comfortably well-off, healthy, sane; he does not seem especially distraught about anything intelligible. At the same time, he neither does nor says anything to endear us to him. The same holds for the other characters: aside from their distinct ages, professions, and ethnicities, which are charged with symbolic significance, they do not reveal enough about themselves for us to establish an empathetic connection to them. Without a central sympathetic character in an understandable predicament, this story does not exactly grip.

How about the dialogues: could they hold philosophical interest? Some, perhaps, but they are hardly scintillating or impassioned, and their insights are far from original. Bagheri's attempt to reach Badii by relating how, in the middle of his own suicide attempt, his life was saved by eating mulberries is probably the most affecting moment in the film because of the actor's earthy warmth, but it is so despite the idea's staleness. Although he and the seminarian reply to Badii's suicidal desires with discourse, this discourse does not constitute much of an intellectual argument.

Finally, the auditory and visual world of Badii and the people he encounters, while bound to be of interest to many foreign viewers, is striking mainly for its austerity. Most of the film takes place in an area outside Tehran that is lightly peopled by men doing agricultural or earth work. Aside from these pockets of routine activity, the land is largely deserted; indeed, in the autumnal afternoon light, its dry hills are uniformly desert brown. Kiarostami has testified that this is one of his favorite landscapes; there is indeed a pastoral quality to the rolling land nurturing and being cultivated by its workers.[3] It would be fair to say, though, that its beauty is not spectacular; nor does Kiarostami employ any cinematic tricks to boost that beauty cosmetically.

So we have a story that is not very dramatic about a character that is not very sympathetic, involving dialogue that is not especially witty or profound, set in a landscape that scarcely bowls over the eye or ear. What, then, keeps us engaged with this film? Why do we not walk out of the theater or turn off the video?

The interesting hook for me is how Badii's impulse echoes that of such a bored and disenchanted film viewer. The opening shot of Badii looking in our

direction for someone to help him exit from life prefigures how we may come to crave release from such a relentlessly dreary film. "Why can't this world be as exciting as that of a normal movie?"—perhaps some such thought is enough to connect Badii with ourselves. Both he and we (at least in certain moods) want out, in which case, Kiarostami's work may be interpreted as developing a central question for our consideration: What might those of us who nevertheless end up affirming the life of this film, like Badii's interlocutors, appreciate that Badii does not? What might Badii and spectators like him, spectators who are tempted to quit the film, see that we are blind to?

"The world of the happy man is a different one from that of the unhappy man."[4] If this observation of Wittgenstein's is true in this case, then in what lies the difference? One answer I want to propose is that it resides in the world's, in the film's, substantiality. To explain what I mean, let me examine what Kiarostami suggests drains a film of substance or gives it such. To the extent that this will entail interpreting his self-consciousness about the nature of film, I will be affirming *Taste of Cherry*'s mediumism. We may then explore how this understanding of the medium may be generalized into two contrasting points of view on the world.

The scene when Badii gets out of his car in the middle of an earth-moving operation, walks around dazed, and then sits down in a cloud of dust, oblivious to a worker's entreaties that he move, represents the nadir of his morbidity. His expression in the dust recalls that of Albrecht Dürer's *Melancholia*. He seems to see nothing but dirt and his shadow cast in it. As if he knew he is in Plato's cave, the image projected on this earth represents not something that animates his interest, but the death that is waiting for him, that he sees no point in evading. Badii's world and life are like a film, a surface illusion transparent to the heavy darkness that will bury us. Such a film is what we see too when we become thoroughly disenchanted with, and disengaged from, what we are looking at, when we realize we are staring at a piece of cloth on a wall. In this fashion, Kiarostami reflects on, and brings to the fore, the insubstantiality of his medium, drawing expressive meaning out of its possible failure to capture our interest with the events it represents. When that happens, our ennui can turn into a meditation on mortality.

But this is not Kiarostami's last word. Bagheri, the only other named character, stands as Badii's alter ego. He sympathizes with Badii because he has experienced similar despair; however, that experience led him to affirm life and he wants to share that affirmation. Thus unlike the military that fears inner emptiness or the clergy that disapproves of it, Bagheri responds as an understanding artist. Indeed, his artistic identity becomes clearer when we recall André Bazin's famous description of cinema as mummifying change.[5] The taxidermist would appear to be speaking for the film medium as a whole, disclosing another side of its nature.

Suppose this medium essentially possessed the potential to remind us of the taste of cherries, of life itself. How does it best exercise this power? Notice that

Kiarostami does not cut to an image of cherries, or film the story of Bagheri's conversion from suicide. How odd that when we come to the most dramatic event in the entire narrative, Kiarostami chooses to present it only indirectly, reducing it to shots of Bagheri talking in the car and of the car slowly winding around the same kind of roads as previously. Many other filmmakers would have launched into a spectacular, forcefully acted flashback with swelling music. Why such drastic understatement? I think the answer must be that Kiarostami wants pointedly to arouse, at this key juncture of life and death, our imagination. What can save Badii is not the taste in its immediacy but the imagination of that taste. (Perhaps this distinction is registered by the slippage in Bagheri's soliloquy from the taste of mulberries to that of cherries.) Likewise, the only way this film, or, Kiarostami suggests, the cinematic medium in general, will touch us is by activating our imagination. That is its true power; that is what gives it substance. By asking us to think of cherries while showing us a car driving in the desert, Kiarostami employs a stark incongruity as a spur. The shadows on the earth will remind us of life if they can prompt us to form our own inner images and sounds of the world offscreen, and to rejoice in that formative power.

A transparent, insubstantial medium and a suggestive, imagination-provoking one: this mediumist offers us two visions of cinema that correspond to the worlds of the happy and unhappy man. Both differ from conventional, escapist cinema. Together, in their contrast, they broach the existential question, why go on? Kiarostami offers these visions for our self-recognition: How are we viewing the film, the world we are in? And his attitude toward the alternatives? It is to acknowledge the truth in both of them and to sympathize with the disenchanted view while affirming the enchantment of the imagination. Badii's estrangement from a world of shadows, his strangerhood, is not simply scandalous pathology. (One wonders whether the film could have found room for an encounter with a psychiatrist.) In Bagheri, it calls forth gratefulness for the small beauties in life, compassion for those who suffer, and generosity. In Kiarostami, it called forth this film, which even as it mummifies the mortal world, can strike us, as the coda emphasizes, with the force of resurrection. Badii may be gone, but the life of the actor who played him, evoking our lives and those that will succeed us, testifies to the ongoing Present.

BACKGROUND AND FOREGROUND

Café Lumière is dedicated to the Japanese master director Ozu Yasujiro on the centenary of his birth and was commissioned by Ozu's studio, Shochiku. One of its delights has to do with the way it slyly and insightfully twists some of the principal conventions and themes of Ozu's films. Still, even if one knows only secondhand about Ozu's devotion to the feel of everydayness, one cannot miss Hou's aspiration to go down that road as far as possible. The Taiwanese's story is amazing in its uneventfulness. Its main character, the twenty-something

Yoko, has just returned to Tokyo from Taiwan. She receives a call from a friend, Hajime, who works at a bookstore and in his free time records the sounds of the subways, assembling them into a work of computer art; she tells him about a nightmare she had. She then proceeds to see Hajime a few times, visit and host her parents, and pursue some research on the composer Jiang Wen-ye whose music we hear during several scenes. In the course of the film, she surprises her parents and Hajime with the news that she is expecting, and declares she has no intention of marrying the Taiwanese father. In return, she is surprised to hear that a woman has been chasing Hajime during her absence. The film closes with a scene of Yoko falling asleep on a subway train, of Hajime entering the car, discovering her, and moving to stand over her, and then of the two of them getting off and pausing on the platform while Hajime records the trains in transit through the station. The last image is a long shot of four trains crisscrossing at an intersection next to Yurakucho station.

Although there is nothing in this story that is manifestly mysterious or confusing, summarizing it is a challenge because it is hard to tell which events, with one exception, are more important than others. This is why I character-ize it as uneventful: it is constantly breaking down into a sequence of equally pertinent or incidental shots. At one moment, Yoko is taking her luggage out of a locker at a crowded train station; at another, she is lying on her back in her parents' living room while calling the cat's name; at another, she casually brings up to her mother that she is pregnant. Pregnancy, of course, counts as a very significant event and when she makes her unexpected announcement her parents and friend naturally respond with concern for how she will handle this change. Yet this new view of Yoko as a woman planning to raise a child alone quickly merges with the general stream of events around her, losing its consequentiality. Dramatic tension around the question of what she will make of her condition is relentlessly dissipated. By the film's end, we appear to be back in an event stream organized by little else than Yoko's central point of view as she goes about her daily life.

Nor does the dedramatization stop there. Although the camera faithfully follows the actions of the main character, it often shoots her from a consider-able distance, emphasizing how she blends into ordinary Tokyo street crowds. Indeed, the film makes it a point to allow her image to be blocked from view by passing people and objects: a central instance of this is when she tells Hajime she is going to have a baby at the exact moment their images are hidden by a pole in the median of the street they are crossing. If the drama of Yoko's pregnancy is drained away by the flow of ordinary events, those events are in turn swallowed up by the daily tidal movements of the city dwellers that Yoko is a part of, a mass that places in diminishing perspective the drama of any single member.

Is this the story, then, of an event that is normally considered extraordinary, an imminent birth, but is portrayed here as just another passing incident to another passerby? Not exactly. Although Hou evidently wants to insist that

life in contemporary Tokyo forms a stream of everydayness that largely stays unbroken, he is also interested in showing how we can learn from that stream to cope with our inner worries. It is true that save for springing the news on her parents and friend, Yoko does not behave in any way but relaxed. But inwardly, she and Hajime are going through a period of anxiety; the deeper drama of the film consists of their attempts to communicate and resolve that condition. They start to do this when they turn to the *tao*.

Despite her nonchalance, Yoko *is* worried about the baby growing inside her, at least unconsciously. This comes out in her dream that Hajime links to the story in Maurice Sendak's *Outside Over There*.[6] In that children's book, the baby that a girl is taking care of is stolen from her by goblins and replaced with a simulacrum made of ice. When Yoko first recounts the dream to Hajime, she is standing by her apartment window hanging laundry; later, she reads in the copy of Sendak's book Hajime has given her that the girl made a serious mistake in going after the baby by climbing "backwards out her window into outside over there."[7] Still later, Yoko telephones another, unidentified person during a night thunderstorm to say that she remembers encountering this book when she was a young girl visiting a temple her biological mother used to frequent before the latter left the family, and that this memory fills her with a "strange feeling." The next day she falls ill. What is it about this story that is troubling her?

One rather transparent answer is that the story connects ambivalence about her baby to her own abandonment as a child. Yoko is not sure she wants this child or whether her mother wanted her. Her uncertainty concerns the solidity of the family, the permanence of its warmth; this worry is a central theme in many of Ozu's films. Yet I also do not think it is insignificant that its source is located in the world outside. Accompanying her preoccupation with the story are numerous shots throughout the film that position her before windows of her apartment, her parent's house, the train station of her youth, the café she frequents, the subways she takes, often looking out. For all her apparent comfort traveling through the city, she fears that it is not entirely hospitable, that it is capable of stealing something precious from her. Although we are not shown her face, we can imagine her expression in the scene when a friend tells her that a woman had recently tried to entice Hajime to go out with her. And we can surmise her sense of loss when she visits the countryside train station of her youth.

This anxiety stands in contrast to Hajime's state of mind. Although he too comes across as easygoing and genial, when he shows Yoko his artwork he discloses a darker side. The work pictures him in a womb filled with blood and walled in by trains. In response to her queries about the figure, he admits that it is "close to tears" and "on the edge." As with Yoko, a surreal image is keyed to a profound apprehensiveness. In his case, it points inward; this is reinforced by the first image of him sitting in front of an open portal leading to the store's interior. Hajime seems to fear that the world outside is cutting him off from human company, trapping him inside in here, the self.

The worries are different, then, yet both inform how their characters regard the city swirling around them. For Yoko, it is fundamentally threatening; for Hajime, isolating. The stage is thus set for them to discover how they can help each other overcome these complementary anxieties. Yoko's face lights up when she first views Hajime's artwork, and over the course of the rest of the film she seems gradually to absorb its meaning. There is much for her to recognize in it: the fragile child inside her; how Hajime, like that child, is worthy of her love; perhaps even a premonition of how the trains will bring Hajime to watch over her. And for his part, when Hajime at the end discovers her sleeping on the train, he seems to recognize, with a flicker of a smile, that caring for her is the way to free himself and join the outside world. If Yoko is in need of help, Hajime is looking to help.

What prepares the way for these epiphanies are forms of communication that, while never breaking the surface of routine small talk, touch the characters in hidden ways. In this respect, the closing image of subway trains emerging at a crossing before returning to subterranean invisibility is apt. Yoko and Hajime's conversation remains as casual and undemanding as ever throughout, yet more and more seems to be *understood* between them, strengthening a bond of trust. In particular, Yoko becomes more aware of Hajime's support for what she wants to do with her life. Similarly, when Yoko's parents, especially her father, find themselves at a loss as to how to comprehend, let alone respond to, Yoko's choice to raise the child alone, they nevertheless try to rest their helpless silence on the deeper understanding supporting the family. All the father can manage is, "Yoko, you like this," putting a potato on her plate before lapsing back into muteness. And the mother, after trying to steer Yoko toward reconsidering her decision, soon gives up, remarking with a big sigh on how far away the father will be (and how far Yoko's own father might as well be), "Thailand." As a depiction of parental bewilderment, the scene is quite funny—yet I also think Hou wants us to see that something does get communicated in this silence all the same, something that makes Yoko stronger the next day. Finally, directly preceding this dinner with the parents is a scene where Yoko interviews the music composer's widow. When Yoko grasps that the Jiangs' was a true marriage of equals, she seems moved by the music in a new way and tries to telephone Hajime. In such oblique fashion, Yoko finds steadying connections to people around her that help her entrust herself to the strange world "outside over there."

The film's penultimate scene, where Yoko and Hajime descend from the train and stand for a time on the platform, represents not only their emergence as a new couple—in keeping with the kind of communication described above, we are shown no grand declarations or exhibitions of passion, only the evidence of a deeper understanding—but also the provisional resolution of their anxieties. As she contemplates their surroundings, he records the sounds of passing trains. Each opens themselves not only to each other but to the ocean of incident

around them: in the foreground, they studiously receive the background. The next moment the camera steps back to place them in that background: we glimpse them in the intervals between cars of a passing train, like so many stills in a moving film. As they unclose themselves to take in the larger city, they join the stream of life running through it, the *tao*, and their worries seem to wash away. Not only do the words of reassurance come to them obliquely, but they also come from other beings besides humans, like so much Cagean sound, all testifying to the flow carrying them together. Could this be what it means to be reborn or to be born in the first place?

Hou's insistence on dissolving the dramas of these characters in the stream of ordinary life is thus no mere stylistic curiosity. It shows us how our inner conflicts may yield to the Present outside. Those anxieties can be expressed in foreground images of surreal juxtapositions, capturing our essential strangerhood. Montage is of course one of the essential features of the film medium. But this medium can also draw our attention away from such fascinating monsters to the all-encompassing, imperturbable, calming backdrop to our lives. There is no filmic image or sound that does not also bring to us this *tao*. In making Tokyo one of the central characters of the film, that of matchmaker and soothsayer, Hou is not only following in the footsteps of the director of *Tokyo Story* (1953) but is also advancing the neorealist critique of and alternative to Hollywood. Like Alex and Katherine in the last scene of Roberto Rossellini's *Journey to Italy* (1954), whose marriage is rekindled by the cry of "Miracle!" somewhere in the crowd around them, Yoko and Hajime are brought together by the haphazard, yet constant, noise of grace. Their intent entry into this stream of events reflects wonder at our very appearance in life.

MOVING BODY

The eponymous, teenage heroine of *Rosetta* could not be more different from Yoko. While the latter is cultured and articulate, Rosetta is relatively unreflective and unverbal. Yoko is dreamy and drifting; her counterpart the very image of a woman at war. The film starts abruptly with Rosetta bursting open a door. All she wants is to keep her job. Yet despite the fight in her flailing and kicking limbs, she is thrown out on the street. We subsequently watch her eke out a living for herself and her alcoholic, messed-up mother, never ceasing to hunt for the salary and respectability that would spring them from the trailer park they have landed in, outside the Belgian industrial town of Seraing. At one point, things take a hopeful turn: she is befriended by a young man, Riquet, who helps her find work manufacturing waffles. But before long she is laid off again. She then turns on Riquet: she divulges to the boss that he has been selling his own waffles at the concessions stand and when Riquet is fired, Rosetta replaces him. Triumphantly, she serves patrons in a spotless white apron on to which she has proudly sewn her name. When she finds herself fighting this time Riquet's

relentless, silent reproaches, however, and when she returns one day to find her mother, who had run away, passed out in front of the trailer, her achievement turns decidedly sour. She quits the job and tries to kill herself and her mother by sealing the trailer and turning on the stove gas; absurdly, though, the gas bottle runs out. While she is laboriously hauling a new one to the trailer, Riquet pounces on her again and the film ends when she finally *sees* him.

What blinded her to Riquet's humanity was her battle to find a place in a mercilessly competitive world. When she thinks she has succeeded, she whispers to herself before going to sleep: "Your name is Rosetta. My name is Rosetta. You found a job. I found a job. You found a friend. I found a friend. You have a normal life. I have a normal life. You won't fall in the rut. I won't fall in the rut. Good night. Good night." For a moment, she is recognizable to the social super-ego that possesses her voice—and thus to herself. Until then, she barely existed; when that recognition is once more snatched away, her desperation knows no bounds. She is ready to treat Riquet as a tool. After blowing the whistle on him, she is initially deaf to his outrage; he has become nothing but an obstacle for her as she was once for the rest of society. To his protests at her crime (beside which his lawbreaking pales: imagine, trying to claim the waffles he makes and sells belong to him!) she replies, "Let me through!" But, of course, the fact that she has been where he is now, on the invisible margins, and that her mother will likely always remain there, makes this pretended incomprehension of what she has done to Riquet impossible to sustain. No amount of forced cheerfulness with customers can dispel her guilt at what her tiny station in life cost. Having to choose between a hypocritical existence and nonexistence, she finally yields to the latter in the most literal way.

In her closing encounter with Riquet, though, she learns she has a third choice. When he appears as she is staggering on her Calvary, hauling the heavy iron bottle, she takes him for an avenging fury. Unable to bear the weight of both her despair and her culpability, this hitherto indomitable woman collapses to the ground in tears. The last thing she is expecting is for him to tenderly help her to her feet. In surprise, she looks up, and for the first time recognizes a fellow sufferer in the same social predicament. The film ends as jarringly as it began on this epiphany; we are given no idea about whether or how this recognition will make a difference to Rosetta's subsequent life. But its intrinsic significance is clear: it is the first moral insight she has had that is rooted not in ideological imperatives but authentic experience. From out of a life of instinctive struggle emerges the conscious seed of an understanding of how her condition involves others, an understanding that brings solidarity.

By sticking to the bare bones of the film's story, I have emphasized its anti-capitalist allegory of fallenness and redemption. The work raises the question of how we can be a community, since in this time and place what brings us together is what divides us. Such a reading, however, should be supplemented with what I judge to be its most important aesthetic accomplishment: its astonishing

corporeality. Rarely has the body of an actor been so closely observed. By this, I am not referring to any nudity; we are spared the cliché of a sexy Rosetta. Nor are the directors interested in exploiting any physical oddities in the actress. Rather, the whole film takes its lead above all from the *exertion* expressed in Rosetta's actions.

The film opens with Rosetta in ferocious motion. The camera follows along close behind, as if straining to keep up. We try to absorb her actions without knowing where she is going with them. Although the pace slackens after this scene, the guiding principle of the work is established. Before anything like a clear dramatic conflict can emerge around which we may form, from a distance, expectations and suspense, there is simply Rosetta's moving body and the wake of interest it broaches that sweeps us away. What is this person doing? Why? What in the world will she do next?

What magnifies this interest is the way the actions are filmed. Although their setting is unusual to most people who can afford to see a movie, they themselves are not: washing, fishing, changing one's shoes, boiling an egg, and so on. Given this familiarity, we would expect attention to be drawn less to what Rosetta is doing with some object than to her interaction with other people around her, highlighted by standard close-ups of facial expressions as she says more or less interesting things. Or, if she is alone, we would anticipate shots that meaningfully relate her to her environment or reveal an inner thought. In the absence of some tricky piece of high-stakes virtuosity, such as defusing a bomb, the normal cinematic focus should be on Rosetta's character as a rounded whole, with its history, complexities, and depths, standing out from what is around her. By frustrating and altering this expectation, the Dardennes open up a new set of expressive possibilities for cinema.

In their approach, all nondiegetic sound or music is eliminated: nothing is permitted to distract from the action on the thoroughly naturalist set. As I earlier remarked, the camera quite literally and from only a few feet trails Rosetta, who spins the narrative thread out of her movements. Rather than being encouraged to imagine that there already exists a story conceived from a god's-eye point of view in which actions are determined by their characters' interrelated, ordered roles, we are constrained to assemble the story ourselves out of after-the-fact, never conclusive, speculative responses to the question of what this person is doing. And since most of this doing is performed either by traveling legs and torsos or by hands and fingers, the camera spends an inordinate amount of time concentrating on these parts of the body in motion. Occasionally, it will swivel to look at Rosetta's face, but as if to insist on the importance of her actions, it will usually find only impassivity. Her curt dialogue is hardly more communicative. Even when she pauses before a moral challenge, as when she hesitates before exposing Riquet to the boss, the pause is more expressive than the blank look; her body consistently acts as an opaque screen blocking access to her mind. Finally, as if to underscore the significance of this physical

movement by echoing it, the camera itself is held and guided by a human body trembling under its weight. Aside from keeping the action in sight, the filmmakers show little interest in composing precisely framed, stable, elegantly juxtaposed images. This primitivist approach to filmmaking appears designed to shift our attention away from Rosetta's interior or exterior worlds, or even from her social connections, and toward her physical work in the world.

Why? Because it is there that the Dardennes find the source of her true passion. To repeat, there is nothing special about this work as such. However, what it demands from Rosetta, and what she unhesitatingly expends on it, is energy. This is a film about the sheer effort it takes for someone in Rosetta's position to stay alive—an effort all the more exacting in that it counts for nothing in society's eyes. It is disclosed in the distinctive ways this particular body moves to perform certain actions under certain circumstances. Capturing that energy is more important for these filmmakers than delving into the character's conscious philosophy, unconscious psychology, or environmental influences. Its drain on her is what she at last recognizes she shares with Riquet; this exhaustion is what transforms the train of movement we have been following into a story with a moral.

By focusing on this relatively unlyrical, undiscursive body and by developing an approach to shooting that correspondingly bears the traces of the cameraman's body under strain, the Dardennes portray action in an initially alienating light. Where is expressed the spirit that renders this activity human? But if we grasp the alternative conception of the actor they are proposing for this medium, one rooted in the pathos of struggle, we may appreciate how they have transformed the material limitations of the person into a sympathetic source of beauty. A comparison with the revelatory thinking and practice of another film director, Robert Bresson, may be useful.[8] Similar to him, the Dardennes evidently restrain their actors from projecting inner thoughts and sentiments and take an interest instead in the automatic habits that show themselves when people act without thinking. Bresson mistrusts the former as a source of theatricality in Fried's sense; he finds in the latter a truer expression of the actor's individuality, of what he or she genuinely has to give to a film. Building on this in their work, the Dardennes set such individual habits against the natural, and more pointedly social, world, and thereby stress their moving vulnerability. Deprived of recognition and under threat of being overpowered by want, our humanity all the more will out.

MONUMENTS

Despite the grandeur of the questions the above films have broached for us— why not die? what is birth? for whom do I exist?—these works are distinctly intimate in scale. Their stories each concern the experiences of small groups of ordinary individuals interacting in a delimited space during a period of days. In contrast, *Ulysses' Gaze* aspires to epic reach. The main character is called by no

name except in the script, where he is referred to as "A."[9] This Everyman, who also happens to be a famous film director, is on a journey of Homeric proportions that takes him across several borders in the Balkans. It also draws him, in his imagination, into other historical periods besides the 1990s, conveyed by Angelopoulos' famous lengthy sequence shots that begin in one time period and end in another. A is searching for three missing reels of film, film that explicitly represents for him this region's "first gaze," a lost innocence. Along the way, he encounters and leaves four women, played by the same actress, who echo the personages of Penelope, Kalypso, Kirke, and Nausikaa in the *Odyssey*. Although he finally finds the reels, the search costs him the lives of a family he joins in war-torn Sarajevo. Whatever innocence he rediscovers would appear to be drenched once more in bloody disenchantment. He resolves to continue the journey—but why, and for what?

The symbolic and self-referential freight of this story may seem alarmingly heavy and this worry is apt to grow when we consider the deportment of the main character. We are given next to no backstory on A; as a result, he does not appear to be distinctly placed in the world, nor does he come across as fully rounded or complex. All we know is that he is going through a personal crisis that is driving him to search for a freshness he fears lost. On the basis of this rather stock motivation, we see him display nostalgic longing, restlessness, resourcefulness, perseverance, and courage, many of the virtues of the original Odysseus. His heroism is unburdened by any internal conflict; the sole exception, perhaps, comes out in his anguished parting from the Kalypso figure. This lack of what we today would consider subjective realism is matched by a corresponding lack of objective verisimilitude. A travels across countries without any luggage or concern for money. His conversations are scarcely plausible: virtually all small talk and pleasantry—indeed, any kind of exchange—has been eliminated in favor of stiff expositions of history and allegorical storytelling decorated with literary quotations and lyric flourishes. His visage remains for the most part set in a mask of somber determination. Who could believe in the existence of such a man?

Furthermore, the story seems held together by a most slender thread. The actions A performs have little cumulative consequence. Instead, his travels take him into and out of a sequence of vignettes, set in different locales and historical periods, without leaving much of a mark on anything or anyone. For all the character's constant movement, culminating at the end in feats of sniper-dodging, he makes little attempt to intervene in the world. As he conducts his search, his main activity is simply that of bearing witness.

Identifying A as a spectator, however, starts to illuminate why Angelopoulos may be content for him to be something of a stick figure. By leaving him so flat and sketchy, Angelopoulos discourages us from projecting ourselves into his supposedly inner experiences. In Brechtian fashion, we are constrained to watch his actions and listen to his words from the outside. (Unlike in the case of Rosetta, though, this is due less to the opacity of the character's body than to the disconcerting

simplicity of his evident motivations.) But what does this hero actually do besides travel? He contemplates the world passing by and devotes most of his talk to the historical background of what he sees. What A may represent for us, then, is a regard on the world of this film that is responsive to that world's past: a gaze, if not a character, with which we may identify.

Suppose, then, we consider A's journey to be a pretext to move this witness on an itinerary through the Balkans and its history, ending, portentously, at Sarajevo. Suppose we appreciate his nostalgic quest and his encounters with the four figures of the mythic Woman less as a credible story and more as a shifting, sentimental undercurrent to the traveling gaze. In other words, maneuvering on the deliberately thin interactions of the characters, suppose the film mainly aims to set up images accompanied by fluctuating moods periodically breaking out into Eleni Karaindrou's plaintive score. What might be the point of using the medium in this way? How might this approach yield aesthetic truth?

The answer lies in what the images are of, in what the story and music are providing accompaniment for, namely, monuments. Angelopoulos is at his most arresting when he presents strikingly formed tableaux that disclose events that have constituted the region. Such tableaux could have been staged in a thoroughly illusionist way via the use of costumes and props on a studio set. Most of the time, though, Angelopoulos insists on working with real sites of history. He appears to be less interested in manufacturing a picture of the past for its own sake or for the sake of theater, as in conventional historical epics and costume dramas, than in drawing forth, in a manifestly fictive manner, the history latent in a specific place in the present. His images, however deliberately composed and supplemented with theatrical, literary, or musical punctuation, stay rooted in the factual existence of this snippet of an old film, this house in a town, this border crossing, this train station, this harbor, this burned-down theater, this bombed-out building. Under his gaze, these things become memorials of another, larger, geographic story.

Perhaps the most sublime example of this imagery is that of a majestic but broken statue of Lenin being ferried on a barge down the stygian Danube for disposal in Germany. Not content to cleverly snap the dustbin of history in action, the camera dwells unhurriedly on the image in order to invite us to remember everything associated with it. Another example, earlier in the film and more subtle, takes place after A and his taxi driver have picked up a Greek lady at the Albanian border who is looking for her sister she has not seen in forty-five years—in other words, since the end of the Greek civil war and the collapse of the communist insurgency. Once they cross into Albania, the film presents us with panoramas of refugees dotting desolate, wintry fields or trudging along decrepit roads, heading for wealthier Greece. They drop the lady off in a square at Korçë that is utterly deserted as the Muslim call for prayer goes out over the old party loudspeakers. Both of these episodes mourn the failure of communism in spaces that are now stamped with that failure.

In the light of this history, A's quest for innocence sheds its arbitrariness and acquires more substance. No longer simply a stereotype animating an otherwise hollow character, we can now appreciate it as a vital counterpoint to the procession of monuments. For each of the latter testify to the area's relentless forces of division and destruction. The space of the Balkans emerges, as A travels through it, formed by strife memorialized in physical scars. No wonder the presence of these wounds spurs A to look for some prior state of social wholeness. The more devastation he sees, culminating in the massacre of the family he entered into, including the daughterly incarnation of the feminine happiness that has been haunting him, that he has had to defer, the more he believes there must be an Edenic gaze that would redeem it. Is this a naïve hope, a piece of innocence in its own right? Perhaps—but it is Angelopoulos' insistence on this hope in the face of centuries of war, his stubbornness without illusion, that draws him to these monuments as if he could see there auspices of utopia.

In the narrative film, we expect its components all to serve the beauty and truth of the story. *Ulysses' Gaze* can be off-putting in the way it violates this rule. It treats its narrative as an extension of its music and puts both in the service of its imagery. A's fictional story discloses, by reacting against, the story of the Balkans in those images. Faced with what these feuding peoples have left behind, the film nonetheless affirms a common, prior innocence as a way of looking forward. Angelopoulos is disenchanted enough to frame this affirmation inside a millennia-old, largely exhausted myth. But the intentness with which he makes the *mise en scène* of this myth continuous with the contemplation of monuments effectively begins to reverse Benjamin's famous observation: "There is no document of culture which is not at the same time a document of barbarism."[10] The Homeric journey continues because the current wars are no less intolerable.

Who Is a Mediumist Educator?

Most of this book has been focused on explaining why we should be concerned with existence and what that concern would imply, particularly for how we may conceive of a culture of modernism. In this concluding chapter, I would like to return to the central role played in this culture by educators. That modernism is essentially educational could sound obvious: what else could it be? one might be tempted to retort. The claim's significance, therefore, depends in large measure on what we construe by education. If the term is merely synonymous for "the communication of something imporant," one might be excused for thinking it platitudinous. Evidently, I find more there than that.

Christopher Higgins has worked out an insightful and useful way of defining education.[1] He suggests that rather than tackling the term head on and trying to grasp the abstract noun behind concrete practices and texts, we should come at it obliquely from the question, what is educative? This would have the virtue of making clear that we are interested above all in certain adjectival qualities, wherever they might reside. Higgins volunteers that "something is educative if it facilitates human flourishing."[2]

He quickly acknowledges this is likely to seem wanting. It substitutes for "educative" three terms that are no less problematic: "facilitates," "human," and "flourishing." What would count as facilitation here? What would it mean to be human? And flourishing, in what sense and by what measure are we supposed to determine that? Higgins's formulation appears to leave the educative just as vague, just as open to competing interpretations, as it was when it was in the hands of informal common sense.

It turns out, though, that the definition was never intended to unify our intuitions about what is educative. Higgins is rather interested in illuminating and mapping the assumptions behind them in the hope that if we can stay on top of these assumptions, we will put ourselves in a better position to resolve eventually some of the debates about these intuitions. He aims to articulate the formal conditions for anything to be even considered educative. These turn out to be threefold: the thing must explicitly or implicitly address the questions

of what it means to be human, what it means for human beings to flourish, and what it means for something to facilitate or move us closer to this state of human flourishing. Our different notions of what is educative will thus yield correspondingly different answers to these questions. Many of these answers and notions are patently reconcilable with each other; for instance, the claim that humans as embodied beings would do well to maintain physical fitness by a regime of regular exercise is ordinarily compatible with the claim that humans as economic beings would do well to secure their livelihood by mastering a useful trade. However, some of these notions are bound to conflict, and in any case, there is the philosophical interest in developing more and more comprehensive visions of the educative. Higgins's overarching, formal definition helps us to analyze these conflicts and parts in terms of positions taken with respect to the trio of interrelated questions, and thus to make more precise, critical judgments about those positions (e.g., to determine that this view of our humanness is too narrow, or that view of how to facilitate human flourishing does not follow from what such flourishing is supposed to be).

We may still wonder whether this mapping system is truly capable of capturing everything we intuitively think could be educative; specifically, we may be uncertain whether these three questions necessarily apply. Although there is need to test it further against refractory cases, I am provisionally convinced that Higgins's triangular diagram presented below in Figure 1 keeps in view a crucial range of concerns involved in education. It enables us to see in particular that our concern about pedagogy, often amounting to one about how to transfer information and skills in the most efficient way possible, can by no means stand for the educational question as a whole. Such a concern is literally meaningless unless it is essentially tied, if only implicitly, to the philosophical-anthropological question of our human nature, on the one hand, and to the ethical or political question, depending on whether we are thinking

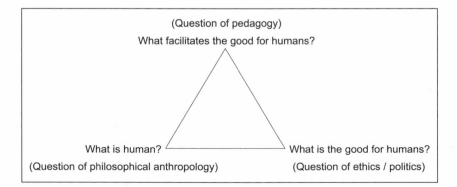

FIGURE 1

in mainly individual or collective terms, of the principal human good, on the other. Serious reflection on our educational practices requires that we devote thought as well to these other fundamental dimensions of ourselves to which these practices are oriented, and vice versa.

So what is entailed by my claim that modernism is educative? Even if we are not for the moment concerned with comparing modernism to other educative works and practices, mapping it onto Higgins's triangle heuristically summarizes the linked theses of the preceding chapters. The results are pictured in Figure 2.

To claim that modernism is educative is to assert it employs artworks that stress their mediums—that is, mediumist works—in order to facilitate the good of presentmindedness for beings essentially distinguished by their stranger-hood. Mediumism draws attention to our strange, existential nature. In this, it resembles other, nonmediumist works of existential pedagogy; like them too, it raises the question of how we should best respond to this nature. Unlike some of them, it directs us to celebrate the Present. Mediumism is thus a kind of pedagogy governed by three theses: that we are intrinsically strangers to all that exists, including ourselves; that the highest good for strangers like ourselves is presentmindedness; and that the best way to move us toward presentmindedness is to study and converse about mediumist works that proceed from a variety of experiences to disclose our nature and its good.

Yet this is not the whole story. I have also argued that this educative practice is opposed by a prevailing practice of miseducation. The latter forms Figure 3.

In this system, the desirable response to our strangerhood is to foster the pseu-dogood of absentmindedness so we may forget about that disturbing condition. The works that most effectively accomplish this are immediacist ones that keep us in a steady state of distraction by concealing their media. Demurring on the clunky term "immediacism," but insisting on the essential role of works of immediacy, I can call this miseducative practice by its more common sobriquet, consumerism.

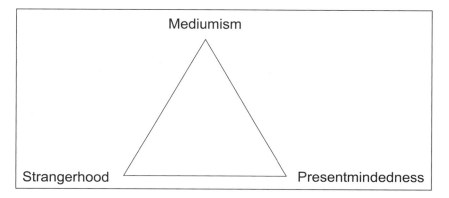

FIGURE 2

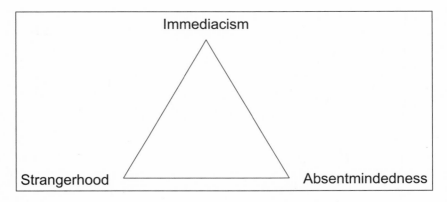

FIGURE 3

Mediumism or consumerism: we may depict this alternative, which echoes Rosa Luxembourg's "socialism or barbarism," by the following pair of linked triangles in Figure 4.

The choice is between, on the one hand, moving with the natural tendency to develop, in ourselves and others, the virtues that truly suit us, and on the other, yielding to the dominant, yet unnatural tendency to support a network of escapist illusions. It is a choice for or against culture. I realize I am courting oversimplification; I admit that this stark summary passes over residual grey areas of complexity and tension that call for still more articulation and qualification. But the final upshot of this book's argument, I cannot overemphasize, must be the challenge to choose between distinct forms of life, to commit ourselves to one and to resist the other. I may be mistaken about some of the features of these forms. Yet what a contradiction it would be if my interest in existential learning did not lead to an affirmation of decisiveness—of decisions made in the absence of complete information but with the readiness to take free responsibility for their consequences—and to the understanding that active exercise of that responsibility, rather than the machinations of fortune, will at the end of the day define my life.

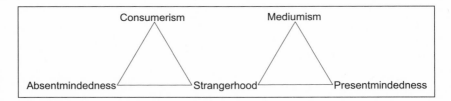

FIGURE 4

Is this your choice, then? Do you recognize yourself in it? If so, you are a mediumist educator.

Where are we likely to make a difference as such educators? In what positions can we work effectively to advance a mediumist culture for existential learning? Our occupational preferences should be guided by a number of considerations. First, there are the questions of what realistic opportunities are within the reach of each of us and of which suit our needs and talents. Obviously, these matters depend on personal history and cannot be usefully discussed here. For the purpose of speaking generally, let me simply rule out exceptional posts of Philosopher King and concentrate on common, middle-class settings. Regarding those, we should next consider in which of them are we are likely to win the ear of a receptive audience, perhaps even one that will be in turn influential. Last but not least, we have to take into account the level of support available to us in these places.

A number of occupations furnish opportunities to make a difference to our collective existential learning; they constitute in the main the material and practical bases of our culture. First, of course, there is that of artistic creator of works of mediumism. Each generation calls for its own confirmations that this cultural tradition is pertinent to the particular predicaments of its day. Depending on the nature of these works and their particular circumstances, the artists involved may gather in circles and rely on supportive collaborators. A second set consists of those occupations that control the means of production, distribution, and publicization of artworks and ancillary texts. Working in art supply stores, museums, dance spaces, broadcasting organizations, or presses, among other places, we can help circulate mediumist works more widely. Another set of influential occupations would be those that stimulate discussion and appreciation of such works. Critics and teachers of certain subjects are normally in a position to fuel, and recruit new converts to, the conversation of existential learning. All of these workers, then, are mediumist educators. They pursue the struggle for existential learning on multiple fronts that enable differently talented individuals to devote themselves to the cause in a variety of valuable and effective ways.

To be sure, each of these occupational settings contains its own constraints, often enforced by the neoliberal ideology and pressures that have driven this learning into decline. In my bailiwick of academia, for example, a number of well-publicized developments have been sapping support for liberal education for some time.[3] Universities and even colleges have been pushing research at the expense of teaching. Meanwhile, as tuitions soar and students and parents grow more concerned about the worth of their education, colleges cater increasingly to the occupational interests of their students, and students are more quickly locked into tightly specialized programs. Their vocational worries become even more pressing when more of them are forced to work to support themselves, or to delay, extend, or break up their college educations. Squeezed

out is the interest in self-understanding; indeed, a passion for existential questions is sometimes reacted to as a sign of pathological maladjustment. Finally, it is fair to say that humanities scholars have become in general less comfortable with thinking about the meaning of life.[4] Such large-scale, institutional changes, leaving aside ones that affect particular schools or regions, amount to a deteriorating climate for existential learning in higher education. It is hardly surprising that in compensation, religious dogmatism is on the rise. Trying to turn around this trend is a daunting challenge and some measure of disappointment is inevitable. Yet the stakes are high, and lend purpose and meaning to our labor we can always rejoice in.

I hope this book can help justify and guide our efforts at mediumist education. It is a hope humbled by awareness of its shortcomings, calling for more work in the future. In particular, I can envisage this theoretical project developing further in at least four directions.

First, there is the task of strengthening the appeal of mediumism by taking stock of its chief competitors in cultural theory. What are the principal critiques of modernism? As modernism languished, what other theories of and movements in culture rose to prominence? And what educational interests capitalized on the disarray around cultural issues? Once we have mapped out the competition, the more substantial challenge is to show that mediumism can not only defend itself from competitors' attacks or benefit from their best points but more tellingly overcome some of their own problems. Now in this book's argument, I have only addressed in passing some of the potential objections of postmodernism and multiculturalism. Those of feminism, postcolonialism, or cultural studies have been barely mentioned at all. Nor has the ever-growing demand for forms of instrumental education been evenly studied. My overriding aim has been to elucidate the idea of mediumism for existential learning in as clear, economical, and straightforward a fashion possible, emphasizing the internal logic of its fundamental concepts. A closer accounting is still owed to its external rivals.

A second direction for future research is the collection of more evidence that establishes the existence of effective mediumist work. This book has claimed we may employ a certain kind of artwork to accomplish certain pedagogical aims. Does that body of work actually exist as described? Does it verifiably lend itself to existential learning? I started to present some supporting cases in chapter 6, but these scarcely scratch the surface of what is needed. It would be of enormous practical assistance as well as reassurance to mediumist educators if they could proceed from a formidable, foundational canon, one that is of course subject to continuous critical revision. And as I argued, it would be especially valuable to find examples that draw on traditions of fine art yet inhabit our contemporary, commercial media.

Closely related to this is the need for research on how to accompany the pedagogy inherent in mediumist works with effective classroom teaching. How can we make such works accessible and appealing to audiences of diverse

ages, backgrounds, and interests? How can we best direct examination of the works so that they become opportunities not so much for lessons in criticism or history, but above all for existential learning? The tradition of the liberal education seminar to which Oakeshott refers gives us a model to start with, but its features should be carefully rethought in the light of the specific challenges and opportunities posed by works that stress their mediums. For example, how might a discussion of Yvonne Rainer's *Trio A* go if learners approach the work from the question of how they normally participate, or not, in the medium of dance? And how might it ultimately, indirectly communicate to them something that nurtures their own self-understanding?

The fourth direction would be to investigate in much more empirical detail the current state of the material bases, which I introduced above, for a culture that would foster existential learning. Such a study would provide invaluable intelligence to our efforts to transform our consumerist culture. It could disclose which areas in the previously mentioned occupations, as well as others, are most ripe for strategic reform.[5]

We remain at the beginning of what must be done for our culture. Indeed, as this book's epigraph vouches, we are "before all beginning."[6] Taken from Rainer Maria Rilke's side of a correspondence with a nineteen-year-old, would-be poet, Franz Kappus, this passage is urging Kappus to be patient with his adolescent turmoil and to let it resolve itself without fighting it. Yet if we allow the passage to be addressed to us as well, we may discover it is registering an experience that transcends any set stage of life or the specific drama of an artistic calling. Beginnings point to projects we have committed ourselves to. But to be before any such commitment is to be radically disoriented, without a sense of who we are or what we stand for; it is simply to exist. Rilke evokes our strangerhood in full recognition of what it means, as Kappus must have confided, to be tormented by riddles of the heart. Kappus was probably hoping for some advice on how to find relief. What he got instead was an expression of sympathetic understanding that deepened his predicament beyond any possibility of escape.

That is not to say Rilke offers him no counsel at all. Rilke encourages him to "love the *questions themselves*." Not only should he not detest them, not suffer his ignorance, doubts, and worries as a plague from which only right answers could rescue him, but he should do more than merely tolerate them as a necessary evil. He should deliberately live them, affirming their existence with his. They are what have been offered to him. "And the point is, to live everything." To grasp at answers and their suppliers without knowing how to live in question, how to exist, is to risk turning temporary moments of resolution into escapist flights from a condition about which he is bound to be reminded. As long as this condition, this dimension of his being, is denied, Kappus cannot fully live the answers either or make them his own.

How, then, does one love and live a question, if not by searching for its answer? This question and the passage that inspired it were first brought to my

attention by my high school freshman English teacher when I was thirteen. I dutifully gave it some thought but I was hardly serious enough to comprehend what the point was. A few years later, when I was closer to Kappus's age and plight in this correspondence, I realized that unlike other school things this passage had stuck. I still had no idea what it was challenging me to do, but I had no doubt about the questions it was addressing in my soul. To hear (and the sense of voice in this writing, even in translation, is so palpable I could have swore there was another person sitting intimately beside me) someone so respect the reality of these questions, a reality so implacable I am enjoined to love it, deeply moved me. I cannot say it directed me to take one course of action over another, or steered me away from mistakes, but it did communicate the gravity of the choices I was struggling to make. Even as I staggered under their weight, I felt buoyed by the realization that this drama of mortal commitment *is* our common, human life itself, carrying the zest of meaningfulness. As the years have passed, my questions have naturally changed, although they remain no less closed to me like "locked rooms." I have learned to look on their doors, their mediums, for opportunities to reaffirm the drama, indeed to give thanks for how it joins me to a cultural community that includes all sorts, such as Kafka's man from the country before the Law.[7] For this learning, and the hope it may spread, I am grateful to Rilke and many, many others.

Notes

CHAPTER ONE

1. See his great deflationary study, *The Conquest of Cool: Business Culture, Counterculture, and the Rise of Hip Consumerism* (Chicago: University of Chicago Press, 1997).
2. For a succinct account of this history, see Raymond Williams, "Culture" in *Keywords: A Vocabulary of Culture and Society*, rev. ed. (New York: Oxford University Press, 1983), 87–93. Terry Eagleton brings the history further up to date in *The Idea of Culture* (Oxford: Blackwell, 2000).
3. Raymond Williams, *Culture and Society: 1780–1950* (New York: Columbia University Press, 1983), 295.
4. Franco Moretti, *Modern Epic: The World System from Goethe to García Márquez*, trans. Quintin Hoare (New York: Verso, 1996), 2.
5. An ingenious example of this is Yve-Alain Bois and Rosalind E. Krauss's book *Formless: A User's Guide* (New York: Zone Books, 1997), which overturns modernism's normal association with formalism.
6. A helpful compendium of the principal approaches to periodizing modernism in the visual arts may be found in James Elkins, *Master Narratives and Their Discontents* (New York: Routledge, 2005), 37–81.
7. See Theodor W. Adorno, *Aesthetic Theory*, trans. Robert Hullot-Kentor (Minneapolis: University of Minnesota Press, 1997).
8. Elkins, *Master Narratives*, 64–65.
9. Fredric Jameson, *A Singular Modernity: Essay on the Ontology of the Present* (New York: Verso, 2002), 169.
10. See Thomas Crow, "Modernism and Mass Culture," in *Modernism and Modernity: The Vancouver Conference Papers*, ed. Benjamin H. D. Buchloh, Serge Guilbaut, and David Solkin (Halifax: Press of the Nova Scotia College of Art and Design, 1983), 260–63; and Thierry de Duve, *Clement Greenberg between the Lines*, trans. Brian Holmes (Paris: Dis Voir, 1996), 43–44. J. M. Bernstein, however, has insisted on the crucial difference Adorno's stress on materiality makes; see his *Against Voluptuous Bodies: Late Modernism and the Meaning of Painting* (Stanford: Stanford University Press, 2006), 63–77.
11. Clement Greenberg, "Modernist Painting," in *Modernism with a Vengeance, 1957–1969*, vol. 4 of *The Collected Essays and Criticism*, ed. John O'Brian (Chicago: University of Chicago Press, 1993), 85–93.

12. Clement Greenberg, *Art and Culture: Critical Essays* (Boston: Beacon Press, 1961); and Clement Greenberg, "After Abstract Expressionism," in *Modernism with a Vengeance*, 121–34.

13. See Bernstein, *Against Voluptuous Bodies*; Thomas Crow, *Modern Art in the Common Culture* (New Haven: Yale University Press, 1996); Arthur Danto, *After the End of Art: Contemporary Art and the Pale of History* (Princeton: Princeton University Press, 1997); Thierry de Duve, *Kant after Duchamp* (Cambridge, MA: MIT Press, 1996); de Duve, *Clement Greenberg between the Lines*; Jameson, *A Singular Modernity*; and Caroline A. Jones, *Eyesight Alone: Clement Greenberg's Modernism and the Bureaucratization of the Senses* (Chicago: University of Chicago Press, 2006).

14. T. J. Clark, "Clement Greenberg's Theory of Art," in *Pollock and After: The Critical Debate*, ed. Francis Frascina (New York: Harper and Row, 1985), 47–63. This essay was also presented at a Vancouver conference and published in its proceedings under the more colorful title, "More on the Differences between Comrade Greenberg and Ourselves," *Modernism and Modernity*, ed. Buchloh, Guilbaut, and Solkin, 169–93. This version ends with an illuminating exchange between Clark and Greenberg. In his essay, Clark scrutinizes two of Greenberg's essays in particular: "Avant-Garde and Kitsch" and "Towards a Newer Laocoon;" both are reprinted in *Pollock and After*, ed. Frascina, on pages 21–33 and 35–46, respectively.

15. Clark, "Clement Greenberg's Theory of Art," 51. I should note more explicitly that in later years, some critics like Greenberg and Fried, as we shall see, distinguished modernism from the avant-garde at the expense of the latter, while others such as Benjamin Buchloh, Peter Bürger, and Hal Foster made their invidious distinction go the other way. For some examples of the latter group's thinking, see Benjamin H. D. Buchloh, *Neo-Avantgarde and Culture Industry: Essays on European and American Art from 1955 to 1975* (Cambridge, MA: MIT Press, 2000); Peter Bürger, *Theory of the Avant-Garde*, trans. Michael Shaw (Minneapolis: University of Minnesota Press, 1984); and Hal Foster, "What's Neo about the Neo-Avant-Garde?" *October* 70 (Fall 1994), 5–32.

16. Clark, "Clement Greenberg's Theory of Art," 53.

17. Ibid.

18. Ibid.

19. Ibid.

20. Ibid., 54.

21. Perry Anderson has insightfully associated these forms with the glamour of new technologies in incompletely modernized societies. See "Marshall Berman: Modernity and Revolution," in *A Zone of Engagement* (London: Verso, 1992), 25–45.

22. Clark, "Clement Greenberg's Theory of Art," 54.

23. Ibid.

24. See Danto, *After the End of Art*, 61–115. I am drawing here on Lyotard's famous definition of metanarrative as narrative that purportedly contains a validation of its own exclusive truth. See Jean-François Lyotard, *The Postmodern Condition: A Report on Knowledge*, trans. Geoff Bennington and Brian Massumi (Minneapolis: University of Minnesota Press, 1984).

25. See, for example, "All the Things I Said about Duchamp: A Response to Benjamin Buchloh," *October* 71 (Winter 1995), 141–43; *Farewell to an Idea: Episodes from a*

History of Modernism (New Haven: Yale University Press, 1999); "Origins of the Present Crisis," *New Left Review* 2 (March-April 2000), 85–96; and "Modernism, Postmodernism, and Steam," *October* 100 (Spring 2002), 154–74.

26. See Clark, *Farewell to an Idea*, 8–10.

27. Walter Benjamin, "On the Concept of History," in *Selected Writings Volume Four*: *1938-1940*, ed. Howard Eiland and Michael W. Jennings, trans. Edmund Jephcott and Others (Cambridge, MA: Harvard University Press, 2003), 392.

28. See Edward W. Said, *Culture and Imperialism* (New York: Alfred A. Knopf, 1993), 80–97.

CHAPTER TWO

1. The snapshot is that of a man standing in front of Café Flore reading a newspaper with the headline, "L'EXISTENTIALISME." It may be found, among other places, in Centre Georges Pompidou, *Paris 1937–1957* (Paris: Centre Georges Pompidou/Gallimard, 1992), 732.

2. Although not to Maxine Greene. She has been blazing trails that connect existentialism and education for most of her career. For example, see her inaugural lecture as William F. Russell Professor in the Foundations of Education: Maxine Greene, *Education, Freedom, and Possibility* (New York: Teachers College, Columbia University, 1975).

3. Michael Oakeshott, "A Place of Learning," in *The Voice of Liberal Learning*: *Michael Oakeshott on Education*, ed. Timothy Fuller (New Haven: Yale University Press, 1989).

4. See her book *The Demands of Liberal Education* (Oxford: Oxford University Press, 1999).

5. See Hans Blumenberg, *The Legitimacy of the Modern Age*, trans. Robert M. Wallace (Cambridge, MA: MIT Press, 1983), 125–226.

6. Oakeshott, "A Place of Learning," 19.

7. Michael Oakeshott, *On Human Conduct* (Oxford: Clarendon Press, 1991), 36.

8. I am adopting here the position of Rorty: see Richard Rorty, *Philosophy and the Mirror of Nature* (Princeton: Princeton University Press, 1979), 17–127. I discuss his argument at length in René Vincente Arcilla, *For the Love of Perfection: Richard Rorty and Liberal Education* (New York: Routledge, 1995), 30–35.

9. Oakeshott, *On Human Conduct*, 37.

10. Oakeshott, "A Place of Learning," 20.

11. Ibid., 23.

12. Ibid., 17.

13. Michael Oakeshott, "The Study of 'Politics' in a University: An Essay in Appropriateness," in *Rationalism in Politics and Other Essays* (Indianapolis: Liberty Press, 1991), 187.

14. Oakeshott, "A Place of Learning," 39.

15. See his essays "Rationalism in Politics," "On Being Conservative," and "The Tower of Babel," in Michael Oakeshott, *Rationalism in Politics and Other Essays* (Indianapolis: Liberty Press, 1991).

16. Perry Anderson has articulated some serious objections to Oakeshott's understanding of democracy—objections that I mainly share. See "The Intransigent

Right: Michael Oakeshott, Leo Strauss, Carl Schmitt, Friedrich von Hayek," in *Spectrum* (London: Verso, 2005).

17. See, among other places, Jean-Paul Sartre, *Existentialism*, trans. Bernard Frechtman (New York: Philosophical Library, 1947), 27.

18. See Jean-Paul Sartre, *Being and Nothingness: An Essay on Phenomenological Ontology*, trans. Hazel E. Barnes (New York: Philosophical Library, 1956), 59–60.

19. Ibid., 60.

20. Martin Heidegger, *What Is Called Thinking?* trans. J. Glenn Gray and F. Wieck (New York: Harper and Row, 1968), 17.

21. The roots of this assumption stretch back to the ancient Greek sense that the cosmos is a place given to illumination. See Blumenberg, *The Legitimacy of the Modern Age*, 243–62.

22. Ludwig Wittgenstein, *Tractatus Logico-Philosophicus*, trans. D. F. Pears and B. F. McGuiness (London: Routledge and Kegan Paul, 1961), 149.

23. Ibid., 7.

24. Richard Rorty, *Truth, Politics and "Post-Modernism"* (Assen: Van Gorcum, 1997), 17.

25. See Jean-Paul Sartre, *Nausea*, trans. Lloyd Alexander (New York: New Directions, 1964), 126–35. This difference between what a thing is and its existence echoes Heidegger's "ontological difference" between beings and Being. See Martin Heidegger, "The Onto-theo-logical Constitution of Metaphysics," in *Identity and Difference*, trans. Joan Stambaugh (New York: Harper and Row, 1969), 42–74.

26. For a lucid explanation of how a person's subjectivity amounts to what it is like to be that person, see Thomas Nagel, "What Is It Like to Be a Bat?" in *Mortal Questions* (Cambridge: Cambridge University Press, 1979), 165–80. His argument also permits me to define, at least roughly, another refractory term, "experience": what it is like to be a person in such-and-such specific and historical circumstances.

27. Wittgenstein, *Tractatus*, 119.

CHAPTER THREE

1. Clement Greenberg, "Avant-Garde and Kitsch," in *Pollock and After: The Critical Debate*, ed. Francis Frascina (New York: Harper and Row, 1985), 23.

2. Ibid.

3. Greenberg, "Modernist Painting," 85.

4. Ibid., 86.

5. Clark, "Clement Greenberg's Theory of Art," 58.

6. Ibid.

7. Greenberg, "Modernist Painting," 86.

8. For instance, see Clement Greenberg, "Avant-Garde Attitudes: New Art in the Sixties," in *Modernism with a Vengeance, 1957–1969*, vol. 4 of *The Collected Essays and Criticism*, ed. John O'Brian (Chicago: University of Chicago Press, 1993), 292–303.

9. It is chiefly over the significance of these works that de Duve and Danto break with Greenberg's modernism; each views Duchamp and Warhol as revolutionary artists and these works in particular as their most consummate. See de Duve, *Kant*

after Duchamp, and Arthur Danto, "Introduction," in *Beyond the Brillo Box: The Visual Arts in Post-Historical Perspective* (Berkeley: University of California Press, 1992).

10. Clark, "Clement Greenberg's Theory of Art," 59.

11. Ibid.

12. Ibid., 60.

13. Sartre, *Being and Nothingness*, li–lii.

14. Ibid., lxi–lxii.

15. Ibid., liii.

16. Ibid., 9–11. By insisting there are experiences of negativity that cannot be analyzed into some positive state of affairs, Sartre acknowledges the truth of those whom Kierkegaard calls "knights of infinite resignation." See Søren Kierkegaard, *Fear and Trembling / Repetition*, ed. and trans. by Howard V. Hong and Edna H. Hong (Princeton: Princeton University Press, 1983), 41–46.

17. Sartre, *Being and Nothingness*, 22–23.

18. This shadowing is movingly pictured in Jasper Johns's series of paintings, *Summer, Fall, Winter*, and *Spring*.

19. This point became the linchpin of his later work on a Kantian aesthetics. See Clement Greenberg, *Homemade Esthetics: Observations on Art and Taste* (Oxford: Oxford University Press, 1999); and Clement Greenberg, *Clement Greenberg: Late Writings*, ed. Robert C. Morgan (Minneapolis: University of Minnesota Press, 2003), 45–102.

20. See Georg Lukács, *The Meaning of Contemporary Realism*, trans. John and Necke Mander (London: Merlin Press, 1963), 17–92.

21. Arthur Rimbaud, "Rimbaud à Paul Demeny," in *Poésies, Une Saison en enfer, Illuminations*, ed. Louis Forestier (Paris: Gallimard, 1973), 202.

22. See Bertolt Brecht, "A Short Organum for the Theater," in *Brecht on Theatre: The Development of an Aesthetic*, trans. and ed. John Willett (New York: Hill and Wang, 1964), 179–205.

23. See Victor Shklovsky, "Art as Technique," in *Russian Formalist Criticism: Four Essays*, trans. and ed. Lee T. Lemon and Marion J. Reis (Lincoln: University of Nebraska Press, 1965), 3–24. Kristin Thompson elucidates and extends this formalist approach in *Breaking the Glass Armor: Neoformalist Film Analysis* (Princeton: Princeton University Press, 1988), 3–46.

24. See John Dewey, *Democracy in Education: An Introduction to the Philosophy of Education* (New York: The Free Press, 1916). From its marvelous opening, in which he distinguishes living from nonliving beings by virtue of the former's capacity to adapt to changes in its environment and renew itself, Dewey draws a direct line to a concept of consciousness as intelligent activity, which he expounds in the book's eighth chapter.

25. A. R. Ammons, "For Harold Bloom," in *Selected Poems: Expanded Edition* (New York: Norton, 1986), 105.

26. Louis Althusser, though, denies that the concept of alienation plays a role in Marx's mature historical materialism. See "Feuerbach's 'Philosophical Manifestoes'" and "On the Young Marx: Theoretical Questions" in *For Marx*, trans. Ben Brewster (New York: Vintage, 1970), 41–86.

CHAPTER FOUR

1. Taylor argues that every notion of who we are implies one, however inchoate, of what is good for us. See Charles Taylor, *Sources of the Self: The Making of the Modern Identity* (Cambridge, MA: Harvard University Press, 1989), 3–107.
2. Michael Fried, "How Modernism Works: A Response to T. J. Clark," in *Pollock and After: The Critical Debate*, ed. Francis Frascina (New York: Harper and Row, 1985), 67.
3. Ibid., 70.
4. See Thomas S. Kuhn, *The Structure of Scientific Revolutions*, 2nd ed. (Chicago: University of Chicago Press, 1970).
5. Fried, "How Modernism Works," 71.
6. De Duve takes Fried's emphasis on conventions one step further and usefully explains how newly charged conventions seal new pacts with new audiences. See de Duve, *Clement Greenberg between the Lines*, 39–86; and *Look, 100 Years of Contemporary Art*, trans. Simon Pleasance and Fronza Woods (Ghent-Amsterdam: Ludion, 2001).
7. Rosalind Krauss relates an anecdote about Fried ascribing Velázquez-sized ambitions to Stella in "A View of Modernism," *Artforum* 11 (September 1972), 48. Fried's explanation of Stella's stress on shape may be found in Michael Fried, "Shape as Form: Frank Stella's Irregular Polygons," in *Art and Objecthood: Essays and Reviews* (Chicago: University of Chicago Press, 1998), 77–99.
8. Fried, "How Modernism Works," 71.
9. See Michael Fried, "Art and Objecthood," in *Art and Objecthood: Essays and Reviews* (Chicago: University of Chicago Press, 1998), 148–72.
10. Ibid., 167.
11. Ibid., 168.
12. See James Meyer, *Minimalism: Art and Polemics in the Sixties* (New Haven: Yale University Press, 2001); *Minimal Art: A Critical Anthology*, ed. Gregory Battock (New York: Dutton, 1968).
13. Fried, "Art and Objecthood," 153.
14. Ibid., 154.
15. Ibid., 155.
16. Ibid., 153, 165.
17. Ibid., 165.
18. Ibid., 166.
19. Ibid., 167.
20. Ibid., 155.
21. Ibid., 160.
22. See Michael Fried, *Absorption and Theatricality: Painting and Beholder in the Age of Diderot* (Berkeley: University of California Press, 1980).
23. Ibid., 100. The first quote from Denis Diderot is taken from his *Essais sur la peinture*, in *Oeuvres esthétiques*, ed. Paul Vernière (Paris: Editions Garnier, 1966), 702; the second from ibid., 713. Both passages are translated by Fried.
24. See Jean-Jacques Rousseau, *Emile or On Education*, trans. Allan Bloom (New York: Basic Books, 1979), especially book 4.
25. Stanley Cavell, "The Avoidance of Love: A Reading of King Lear," in *Must We Mean What We Say? A Book of Essays* (Cambridge: Cambridge University Press, 1976), 267–353.

26. Ibid., 333–34.
27. Indeed, this essay broaches a theme that Cavell will spend virtually his entire career elaborating: the critique of skepticism as theatrical. Since skepticism captures the epistemological implications of our strangerhood, the pertinence of his critique to my argument appears clear. See ibid., 322–26.
28. Taylor roots the distinction between these two forms of moral thinking in that between a modern, naturalist world and a more classical one marked by important qualitative distinctions. See Taylor, *The Making of the Modern Self*, 79–80.
29. See the discussion of "equipmental being" in Martin Heidegger, *Being and Time*, trans. John Macquarrie and Edward Robinson (New York: Harper and Row, 1962), 95–107, and of "standing reserve" in Martin Heidegger, "The Question Concerning Technology," in *The Question Concerning Technology and Other Essays*, trans. William Lovitt (New York: Harper and Row, 1977), 3–35.
30. A cogent account of the dangers posed to us by the inflation of instrumental reason may be found in Charles Taylor, *The Ethics of Authenticity* (Cambridge, MA: Harvard University Press, 1992), 1–23 and 93–108.
31. See Søren Kierkegaard, *Concluding Unscientific Postscript to* Philosophical Fragments, trans. Howard V. Hong and Edna H. Hong (Princeton: Princeton University Press, 1992).

CHAPTER FIVE

1. In this vein, Bernard Smith redescribes modernism as the art of the "formalesque." See his *Modernism's History: A Study in Twentieth Century Art and Ideas* (New Haven: Yale University Press, 1998).
2. This phrase is Paul Ricoeur's; he develops an illuminating contrast between this approach to interpretation and the hermeneutics of faith. See Paul Ricoeur, *Freud and Philosophy: An Essay on Interpretation*, trans. Denis Savage (New Haven: Yale University Press, 1970), 26–36.
3. See Rousseau, *Emile*, 38–39.
4. For Dewey's critique of Rousseau's philosophy of education, see Dewey, *Democracy and Education*, 111–23. In my experience, this critique has become the standard line on Rousseau among contemporary American philosophers of education.
5. Blaise Pascal, *Pensées*, trans. A. J. Krailsheimer (New York: Penguin Books, 1966), 67.
6. Ibid., 68.
7. Theodor W. Adorno and Max Horkheimer, *Dialectic of Enlightenment*, trans. John Cumming (London: Verso, 1979), 126–27.
8. Karl Heinz Bohrer has written very insightfully about the emergence of "suddenness" as a central experience in modern literature; what he does not explore is how this experience also became a hallmark of the commercial media. See his *Suddenness: On the Moment of Aesthetic Appearance*, trans. Ruth Crowley (New York: Columbia University Press, 1994).
9. Greenberg, "Avant-Garde and Kitsch," 27–28.
10. See Theodor W. Adorno, "The Schema of Mass Culture," in *The Culture Industry: Selected Essays on Mass Culture*, ed. J. M. Bernstein (New York: Routledge, 1991), 63.

11. See the classic essay, Louis Althusser, "Ideology and Ideological State Apparatuses (Notes towards an Investigation)," in *Lenin and Philosophy and Other Essays*, trans. Ben Brewster (New York: Monthly Review Press, 1971). Shortly below, I venture an interpretation of how Althusser's theory of ideology here fits the account I am developing of our diverting, consumerist media.

12. See Sartre, *Being and Nothingness*, 47–54.

13. See in particular Rousseau's approach to the first part of childhood, his "negative" education, in book 2 of *Emile*, 77–163.

14. See Ellen Meiksins Wood, *The Retreat from Class: A New "True" Socialism* (London: Verso, 1998).

15. See Pierre Bourdieu, *Distinction: A Social Critique of the Judgment of Taste*, trans. Richard Nice (Cambridge, MA: Harvard University Press, 1984) and Serge Guilbaut, *How New York Stole the Idea of Modern Art: Abstract Expressionism, Freedom, and the Cold War*, trans. Arthur Goldhammer (Chicago: University of Chicago Press, 1983).

16. See Harold Bloom, *The Western Canon: The Books and School of the Ages* (New York: Harcourt Brace and Company, 1994), 1–41. Unfortunately, there is a haranguing tone to his writing here; the essentials of his argument can be more soberly deduced from his groundbreaking studies of poetic influence. See the tetralogy: *The Anxiety of Influence: A Theory of Poetry* (New York: Oxford University Press, 1973); *A Map of Misreading* (New York: Oxford University Press, 1975); *Kabbalah and Criticism* (New York: Seabury Press, 1975); and *Poetry and Repression: Revisionism from Blake to Stevens* (New Haven: Yale University Press, 1976). I might add that although Bloom differs from Eliot in his estimation of the Romantics, they are both defenders of the specifically aesthetic value of literary tradition.

17. Fredric Jameson, *Postmodernism, or, The Cultural Logic of Late Capitalism* (Durham: Duke University Press, 1991), 47.

18. Ibid.

19. Ibid.

20. See Leon Trotsky, *Literature and Revolution*, ed. William Keach, trans. Rose Strunsky (Chicago: Haymarket Books, 2005), 154–76.

21. See Louis Althusser, "Philosophy as a Revolutionary Weapon," in *Lenin and Philosophy and Other Essays*, trans. Ben Brewster (New York: Monthly Review Press, 1971).

22. See Marshall Berman, *All That Is Solid Melts into Air: The Experience of Modernity* (New York: Penguin Books, 1988), 13, 15, and passim.

23. Benjamin, "On the Concept of History," 395.

24. Ibid., 391.

CHAPTER SIX

1. T. J. Clark, "Malevich Versus Cinema," *The Threepenny Review* (Spring 2003), http://www.threepennyreview.com/samples/clark_sp03.html (accessed September 12, 2008).

2. A cogent discussion of the distinctive narrative forms of the art film, which nevertheless retains the problematic term, may be found in David Bordwell, "The Art

Cinema as a Mode of Film Practice," recently republished in *The European Cinema Reader*, ed. Catherine Fowler (New York: Routledge, 2002). This article was later expanded into David Bordwell, "Art-Cinema Narration," in *Narration in the Fiction Film* (Madison: University of Wisconsin Press, 1985). Still later, he links this cinema to modernism in David Bordwell, "The Return of Modernism: Noël Burch and the Oppositional Program," in *On the History of Film Style* (Cambridge, MA: Harvard University Press, 1997).

3. Kiarostami professes his love for this location in his film, *Ten on Ten* (2003), a series of "lessons on the cinema."

4. Wittgenstein, *Tractatus*, 147.

5. See André Bazin, "The Ontology of the Photographic Image," in *What is Cinema?* ed. and trans. Hugh Gray (Berkeley: University of California Press, 1967), 14–15.

6. See Maurice Sendak, *Outside Over There* (New York: Harper Collins, 1981).

7. Ibid., 13–14.

8. See Robert Bresson, *Notes on the Cinematographer*, trans. Jonathan Griffin (London: Quartet Books, 1986).

9. See Andrew Horton, "'What Do Our Souls Seek?': An Interview with Theo Angelopoulos," in *The Last Modernist: The Films of Theo Angelopoulos*, ed. Andrew Horton (Westport, CT: Greenwood Press, 1997), 102–3.

10. Benjamin, "On the Concept of History," 392.

CHAPTER SEVEN

1. See Christopher Roy Higgins, "Practical Wisdom: Educational Philosophy as Liberal Teacher Education" (PhD diss., Columbia University, 1998), 78–112.

2. Ibid., 85.

3. A recent, eloquent review of some of these discouraging trends I mention below may be found in Stanley N. Katz, "Liberal Education on the Ropes," *The Chronicle of Higher Education*, April 1, 2005.

4. This embarrassment is perceptively discussed in Anthony T. Kronman, *Education's End: Why Our Colleges and Universities Have Given Up on the Meaning of Life* (New Haven: Yale University Press, 2007).

5. Useful guidelines for such an investigation may be found in Raymond Williams, *The Sociology of Culture* (Chicago: University of Chicago Press, 1995).

6. Rainer Maria Rilke, *Letters to a Young Poet*, trans. M. D. Herter Norton (New York: W. W. Norton and Co., 1954), 34–35.

7. See the celebrated parable in Franz Kafka, *The Trial*, trans. Willa and Edwin Muir, rev. E. M. Butler (New York: Schocken, 1968), 213–15.

Index